Dear Marie,

I've always been pleased with your love for books. I am increasingly amazed with how much you read + how fast you read. I also know you to be a very good writer - please keep up your desire to write ok? You will have great adventures in your life. Be sure to record those adventures so the world can see what you've accomplished through your writing.

Congratulations on graduating to the next level. Remember, in life there is ALWAYS a next level so keep your chin up + forge onward!

I love you Marie; you make me feel very proud - ALWAYS.

love,
Dad.

Dear Marie: 5/30/06

I wish you only chappiness and joy in life. May these female writers inspire you. You are a very talented writer - never let go of your passion for writing.

Love, Mom

WOMEN WRITERS

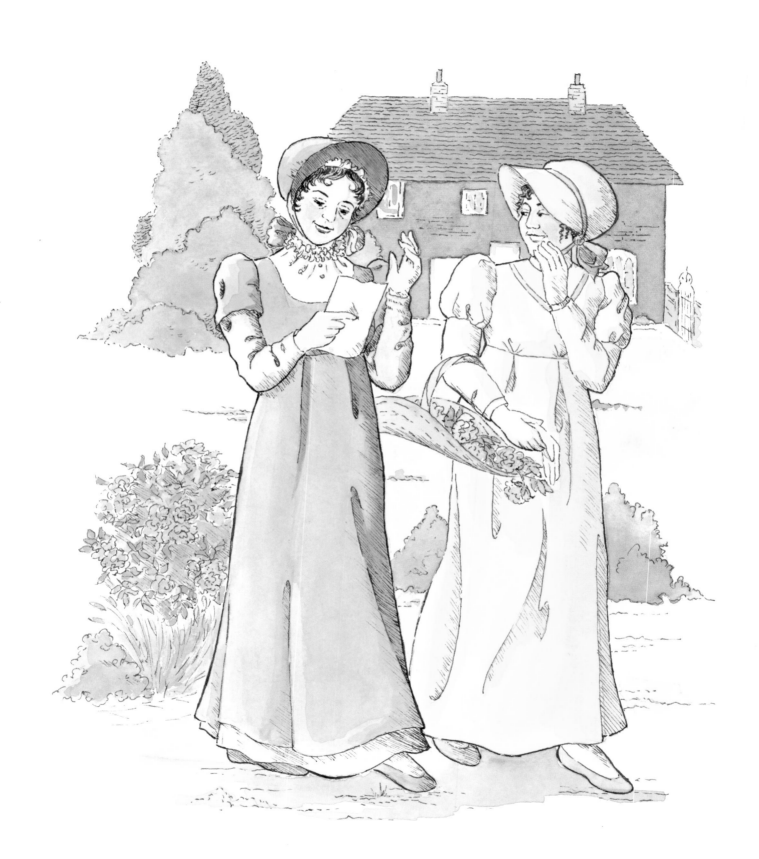

WOMEN IN THE ARTS

WOMEN WRITERS

by Rebecca Hazell

Abbeville Press Publishers

New York London

For Kerrie, whose idea this was

ACKNOWLEDGMENTS

*Thank you to Kerrie Baldwin, my editor, for everything; to Ursula Le Guin, who allowed me to use
her translation of the Gabriela Mistral poem included in this book;
to Betty de Shong Meador for permission to quote from her translation of Enheduanna's poem;
and to all the friends who lent me photos and books for several of the women included here
as well as to Darcia Labrosse for her advice on my illustrations. Thank you to Misha Beletsky
for his suggestions on my work and for designing this book.
And, as always, thank you to my wonderful family, whose tolerance for late dinners seems boundless.*

Editor: Kerrie Baldwin
Designers: Julietta Cheung and Misha Beletsky
Production Manager: Louise Kurtz

Text and illustrations copyright © 2002 Rebecca Hazell. Compilation,
including selection of text and images, copyright © 2002 Abbeville Press.

Printed in Hong Kong

First Edition
10 9 8 7 6 5 4 3 2 1

Library of Congress Cataloging-in-Publication Data

Hazell, Rebecca.
Women writers / by Rebecca Hazell.—1st ed.
p. cm. — (Women in the Arts)
Includes bibliographical references.
ISBN 0-7892-0697-8 (alk. paper)
1. Women authors—Biography—Juvenile literature. I. Title. II. Series.

PN471 .H39 2002
809'.89287—dc21
2002066548

CONTENTS

INTRODUCTION

Welcome to the wonderful world of women writers. In this book you'll visit different and times and places as you learn about the lives and thoughts of many different women. Although for centuries professional writing was a career dominated by male voices, exceptional women writers around the world have made themselves heard, too, sometimes enduring mockery and even slander not only from men but from other women. But men and women alike have also been inspired by what such women have had to say, because they have often approached universal themes—love, relationships, faith, death, and the meaning of life—with new ways of thinking about them.

This book is divided into different sections based on major themes. You'll find a short section on women who wrote for children, another on those whose main topic was love. A third section is devoted to women who explored the challenges of today's world, and the last features women who wove spirituality into their poems and stories.

All these women were and are vital, sensitive people whose lives and words have ranged from the spiritual to the rebellious, from the sad to the joyous. All of them put their life experiences, understanding, imaginations—and their hearts—into the stories and poems they wrote. In doing so, they have shown us not only what it has meant to be a woman in other times, but also what it means, at all times, to be human.

Perhaps this is why reading is such a delight altogether, for underneath our differences, we share so much. I hope you will enjoy reading about these special ladies and that, having been inspired by their lives and ideas, you'll explore what they and others like them have written.

Through a Child's Eyes

D o you remember, when you were very small, how huge and bright the world seemed, how alive everything was? A caterpillar inching along a leaf, clouds changing shapes in a brilliant blue sky, the roar of a car engine: Every detail of life had a certain kind of magic to it—a sharpness and a fullness. To see this way for all our lives is an extraordinary gift, and certain authors not only have it but also are able to share it with others, perhaps by writing for children. You might have already read their stories, and now you can read about the lives of two of these world-famous women whose books have been loved ever since they were first published. Their secret for success? They never forgot how to see through a child's eyes.

9

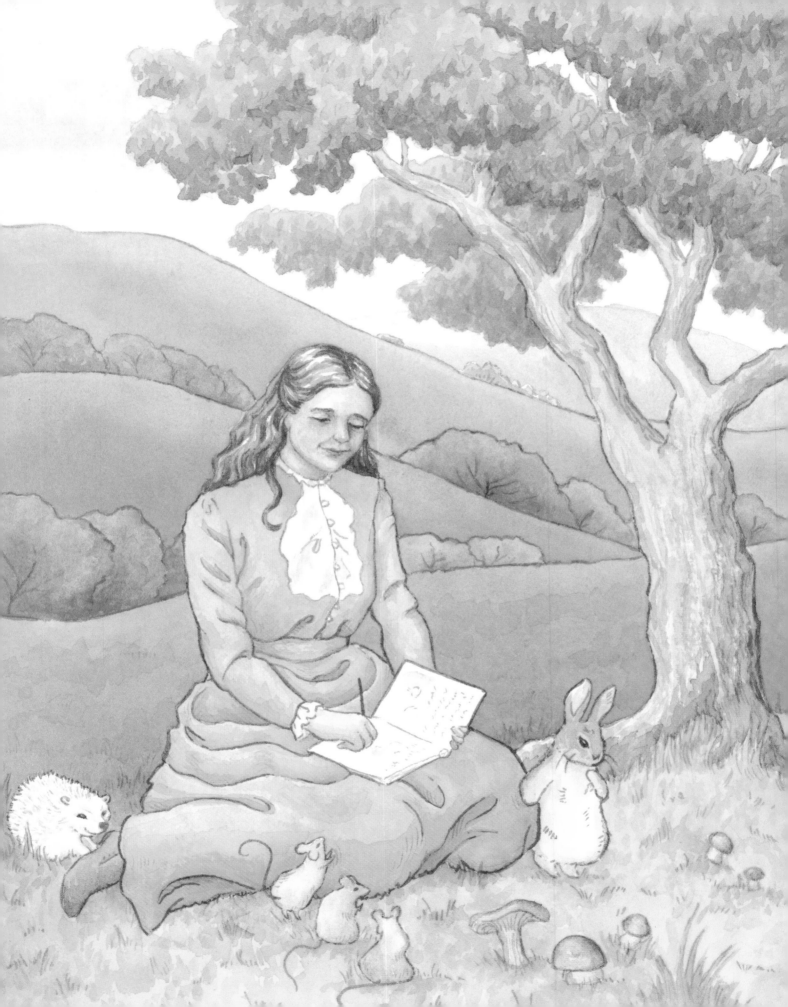

HELEN BEATRIX POTTER

[1866–1943]

"My dear Noel, I don't know what to write you,
so I shall tell you a story.
About four little rabbits whose names were—
Flopsy, Mopsy, Cottontail and Peter."
—a get-well letter to a young friend, September 1893

I t's a drab London day in 1893, and Beatrix Potter is at her desk writing a letter to Noel Moore, the little son of her former governess. She occasionally glances out of her third floor window, scarcely noticing the bars on it anymore; they've been there since this room was her nursery. Once they protected her from falling out, but now they merely symbolize the way she lives, virtually caged in by her parents, both physically and emotionally. Nonetheless, Beatrix has found two ways of escaping the bars around her life: pets and imagination. While she pens her letter and draws little pictures of three good rabbits and one naughty one, her own pet rabbit, Benjamin, snoozes on her lap. Birds chirp in cages behind her; her pet mice, Tom Thumb and Hunca Munca, stir in their sleep; and her hedgehog, Mrs. Tiggy, rustles about in her box. Unknown to Beatrix, this letter contains the seeds of a fulfilling future, where her imagination will allow her favorite animals to live forever on the pages of her books.

Beatrix was raised and educated by nannies and governesses and saw little of her wealthy, snobbish parents until she was old enough to behave in

company. She got sick very easily, and her mother so feared germs that she kept her daughter isolated from other children. Instead of friends, Beatrix had books and pets, both of which sparked her imagination. She had a gift for seeing animals as both earthly and magical, and possessing unique personalities. When her brother Bertram was born, she finally had a play-mate, and as he grew older, she drew him into her enthusiasms. Over the years, between the two of them, they adopted rats, guinea pigs, hedgehogs, lizards, a tortoise, an owl, a falcon, a crow, bats, dormice, ferrets, snakes, caterpillars, snails, and frogs, in addition to the usual dogs and cats. Both were talented artists and spent many happy hours drawing their menag-erie. After Bertram went away to school, Mr. Potter even hired a teacher to give Beatrix art lessons in addition to her regular lessons. When she was old enough, he sometimes took her to galleries and to visit an artist friend of his.

But most important to Beatrix were the summer holidays the family took every year, first to Scotland and later to the Lake District in northwest England, where famous authors like Charlotte Brontë had once visited. There the children were able to roam freely and explore farms, hills, coun-try lanes, tangled woods, buttercups, foxgloves, and forget-me-nots; to Beatrix it was all fairyland in real life. When she was fifteen, she began a journal and wrote in it almost every day until she was over thirty. Using her own secret code and miniscule handwriting to prevent anyone from prying, she recorded everything she saw and did. She also drew whatever interested her, from scenery to mushrooms, and became so skillful that one adult friend called her Miss Mycologist ("mushroom expert"). She even considered a career as a scientific illustrator.

Just as Beatrix reached young adulthood, illness struck hard. In 1885 and again in 1887, rheumatic fever damaged her heart and left her with a bald spot on her head. But despite such setbacks, she began to step out into the world. She visited galleries, museums, and her former governess, now Mrs. Moore, whose children became the friends she'd never had in childhood. She wrote them letters that told enchanting little stories about animals that behaved much as humans do. Sometimes her mother still refused to let her go out, however, even when she was approaching thirty!

While keeping her sense of childlike wonder, Beatrix slowly gained self-confidence. Throughout the 1890s she sold little paintings to greeting card

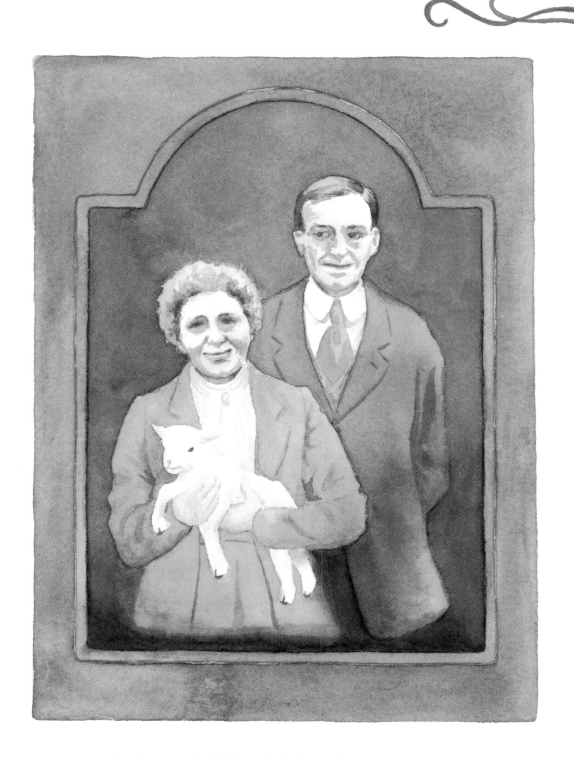

*Happily married to William Heelis, Beatrix Potter later raised animals
instead of just writing about them.*

companies. In 1901, she finally wrote and illustrated her first book. At first, she tried to sell it to a commercial publisher, but after six rejections, she published it at her own expense. Made small for small hands and with short text for young readers, it was based on her 1893 letter to Noel Moore—and sold out in two weeks. Meanwhile, a publisher did buy it, and *The Tale of Peter Rabbit* was launched for Christmas 1902. It was a runaway success, and thereafter Beatrix published two books a year for over a decade. All of her sense of delight in the natural world poured out into a perfect marriage of pictures and text. In them, she created an imaginary world that was so true to nature that it made you believe that rabbits and mice, hedgehogs and frogs actually led secret lives much like our own.

Beatrix's life changed in other ways. When she was thirty-nine, she fell in love and became engaged to one of her publishers, despite her parents' objections. Tragically, shortly after their engagement, her fiancé fell ill and died, leaving her quietly heartbroken. But she continued writing. She also bought land in the Lake District and, whenever she could, retreated to her little farm. As her books brought in money and she bought even more land, she grew increasingly independent of her parents.

By 1913, she had become a middle-aged farmer, spending as much time as she could in her country home, writing her stories and basing the illustrations on the world around her. All of them were set in real places, indoors and out, with people and animals she knew. Her neighbors even began competing with one another to get their farms and pets into her stories.

Over the years, she and her country lawyer, William Heelis, had formed a deep attachment to each other, and despite her parents' disapproval, she agreed to marry him. Only when her brother Bertram revealed that he'd been secretly married to a farm girl for years did they accept the match, since Mr. Heelis was more acceptable to them than Bertram's wife. Beatrix married that same year.

As time passed and her eyes grew weaker (loyal to older times, she wanted no new-fangled electricity in her house), Beatrix stopped writing and devoted herself to country life, her happy marriage, her sheep and other animals, and the National Trust, a nature conservancy. She eventually gave or sold more than four thousand acres of land to the Trust, and she is partly responsible for much of the Lake District remaining unspoiled even today. Ever private, she rejected publicity, even though

her books were selling around the world in several languages. Instead, she helped raise money for charity by donating illustrations for greeting cards, or visited with the Girl Guides she'd allowed to camp on her land, or went fishing with her husband. The only new visitors she welcomed were Americans, whom she thought were less nosy. Because of her friendship with an American librarian, she wrote one book, *The Fairy Caravan*, especially for her readers in the United States.

Beatrix Potter loved roaming the hills alone, careless of her appearance. Once one man mistook her for a homeless person. But with age came illness, and as she became bedridden, she had to rely more and more on memory to keep her love of life alive. Yet those memories were so happy that she felt no regrets. She died peacefully in 1943, but around the world her gently humorous stories keep her sense of magic and wonder alive, drawing children into a marvelous world just small enough to hold in their hands.

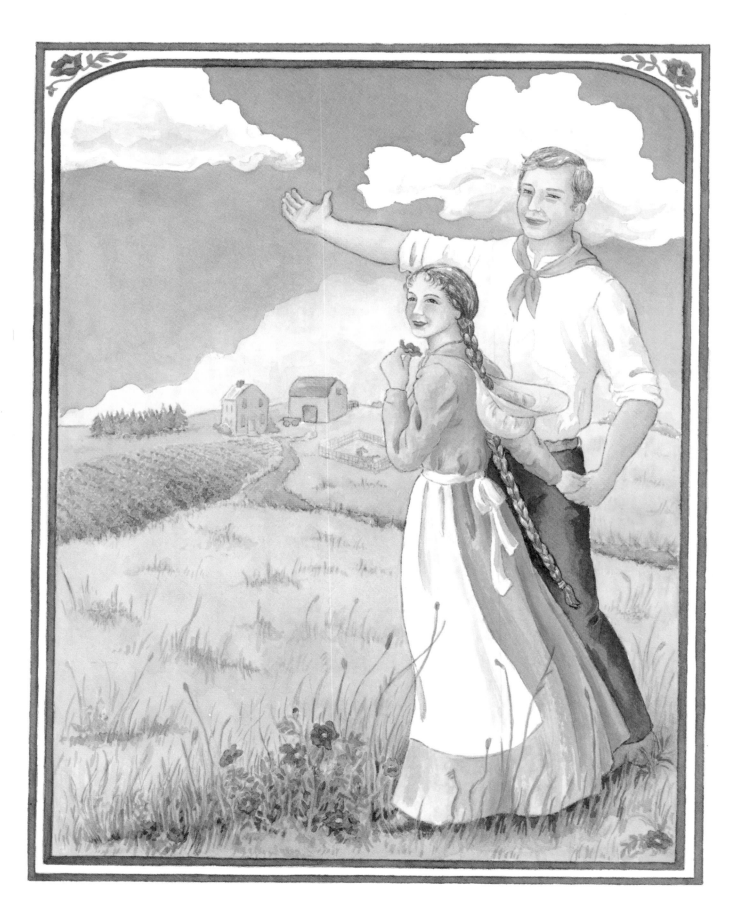

LAURA ELIZABETH INGALLS WILDER

[1867–1957]

"I had seen the whole frontier, the woods, the Indian country,
the frontier towns, the building of the railroads in wild,
unsettled country, homesteading, and farmers coming in to
take possession."
—Mrs. Wilder explaining why she wrote her books

The year is 1880. Two sisters walk arm in arm among the spring prairie grasses in Dakota Territory. Mary, sunbonnet firmly on her head, is fifteen. Laura is thirteen, and as usual her bonnet dangles down her back. Laura used to envy her sister for having blond hair instead of brown, for being so good, and even for the way her bonnet stayed on while Laura's always slipped off. But nowadays, her attitude has changed. Not long before they moved here, their mother and all three of Laura's sisters had been stricken with scarlet fever and nearly died. Mary went blind. Laura has become Mary's "eyes," and she paints pictures for her with words: wild spring roses that scent the breeze; squawking blackbirds swooping and diving; vivid blue sky so huge that it dwarfs the massive clouds that cast shifting shadows on the waving grasses. She shares with Mary how still and empty the prairie feels, and how endless. Laura is becoming a storyteller.

Laura Ingalls was born a year after Beatrix Potter, in an entirely different world. While she shared Beatrix's love for nature and its beauty,

17

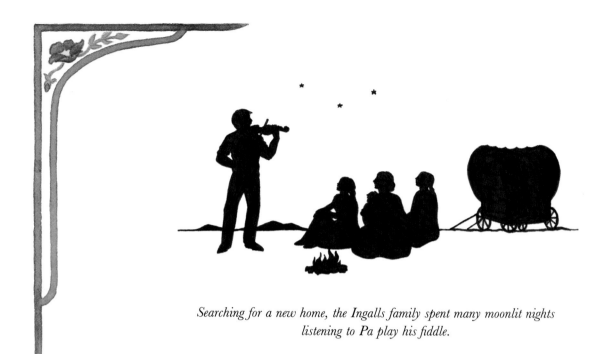

Searching for a new home, the Ingalls family spent many moonlit nights listening to Pa play his fiddle.

Laura was a pioneer girl. Her autobiographical books traced her family's path from Wisconsin to Missouri, Kansas, Iowa, and South Dakota, describing a world both beautiful and brutal, a family that pulled together, and a great migration of people searching for a better life.

When Laura was young, her father, a trapper and farmer, had "restless feet"; whenever the countryside got too crowded and the wild animals had left, he moved his family on. They eventually became the first settlers on the empty South Dakota prairie where Native Sioux tribes had once lived until forced onto reservations. By then the Ingalls' had moved so many times that Pa had finally agreed to stay put. When a new town, De Smet, grew up nearby, they lived there in wintertime.

Laura had already had many kinds of jobs by then, from working as a dishwasher in a café to sewing buttonholes for a dressmaker to teaching school at age sixteen, but she finally became a farmer's wife when she married Almanzo Wilder at eighteen, having insisted on leaving out the word "obey" from her wedding vows. Her books for children end with the early days of her marriage. However, her life was just beginning; she and Manly, as she nicknamed Almanzo, spent almost seventy happy years together—a team, as Laura would say. Nor did she think of herself as Laura Wilder, future famous author. Manly called her Bess (short for

Elizabeth), to distinguish her from his sister, also Laura, and "Bess" tied her dreams as well as her name to his.

Although they soon had a daughter, named Rose after the wild prairie roses, in their first years of marriage disaster followed disaster. Hail and drought killed their crops, their barn caught fire, and later, their house burned down only days after their baby boy had died. Then the young pair was stricken with diphtheria and nearly died; Manly limped for the rest of his life. They eventually lost their homestead, but rather than pity themselves or become bitter, they picked up and went on. Nonetheless, decades later, when Laura wrote about this part of her life in *The First Four Years*, she set her manuscript aside, perhaps deciding the memories were too painful. It was published only after her death.

The young couple tried life in Minnesota (too cold for Almanzo) and Florida (too hot for Laura). Finally they returned to De Smet and worked at various jobs in town to save enough money to start over. In 1894, they headed south in a covered wagon, finally buying land in the Ozarks region of Missouri. Laura described that journey in a diary that Rose found after her death. Rose wrote an introduction and postscript for it, and published it as *On the Way Home*. For, in Missouri, Laura and Almanzo found a true home.

They called it Rocky Ridge Farm because it was so stony. Living at first in a one-room log cabin, little by little they cleared land; planted apple orchards; grew wheat, strawberries, grapes, and vegetables; raised chickens and livestock; and finally prospered. With their loving attention, everything thrived and grew beautiful. They built a house with lumber and stones from their property and brought running water into it from a nearby spring. Manly put huge windows in on all sides so that Laura could see ever-changing "pictures" of the farm. Over the years they bought and farmed more land; by the time the Great Depression hit, they were able to help out many families on welfare.

Meanwhile, Rose grew up, married, and became a famous novelist and international journalist. In 1911, Laura began writing, too: articles about farm life for local magazines. Passionate about education, she also helped start women's clubs and a library. In 1915, she traveled to San Francisco by train to visit her daughter, a trip utterly different from the slow covered wagon rides of her childhood. Her letters to Almanzo about seeing

the ocean and the Panama Pacific Exposition were eventually published as *West From Home.*

But Laura didn't begin writing for children until she was over sixty. In the early 1930s, Rose asked her mother to write about her childhood. Most of the Ingalls' had died by then, and Rose realized that important memories were about to be lost. With her daughter's expert help, Laura wrote not a memoir but a story for children, to show what frontier life had been like and "what it is that made America as they know it." In her first book, *The Little House in the Big Woods*, she told of life in the forests of Wisconsin, but for dramatic effect, she changed time and events, adding family stories to fill out her memories. She'd intended to write only one book, but fan mail flooded in asking for more. So she wrote *Farmer Boy*, about her beloved Manly's childhood. But readers from around the world wanted still more, so Laura wrote six more books. Again, for the sake of good storytelling, she left out less interesting episodes, like working in a hotel in Minnesota, or sad ones, like losing a baby brother.

But the basic story is accurate: lives enriched by courage, humor, resourcefulness, and faith. Readers imagine Pa Ingalls' fiddle music, or the scent of baking bread, or playing in a creek right next to a sod home. They suffer with the Ingalls' through prairie fires, plagues of grasshoppers, crop failures, illness, and harsh winters. Despite such travails, children are drawn to this family united by love, just as they have seen themselves in spirited Laura, who preferred climbing trees to sedately sitting indoors with the other girls. And like Beatrix Potter, Laura shared her sense of the magic of life, not through fantasy but through appreciating details like the flavor of an orange or the scent of newly sawn planks.

Laura was well into her seventies when she finished writing her books, though she still answered fan mail. Her standard reply was, "Today… so many things have made living and learning easier. But the real things haven't changed. It is still best to be honest and truthful; to make the most of what we have; to be happy with simple pleasures and to be cheerful and have courage when things go wrong." Almanzo died when he was ninety-two, and Laura lived another eight lonely years without him. Together they had found happiness in simple things: hard work that they enjoyed, caring for their world, and loving each other.

Love's Different Faces

Love is central to our lives from the time we are nurtured as babies. As we grow older, we share love with our family and friends. And, as adults, we also give and receive love from mates and perhaps children and grandchildren. And, of course, we may express love not only for other people but also in learning, in working, and in doing other things we enjoy. It's no wonder, then, that one of women writers' main subjects throughout history has been love: between man and woman, between friends, between parent and child, and for the world we live in.

Yet there are as many ways to love as there are people, some of whom spend their entire lives seeking it. In addition, love may be expressed very differently from one culture to another. In the next section of this book, we'll look at the lives of several women who both sought and wrote about love, each from an individual point of view that reflected their personalities as well as their culture and times.

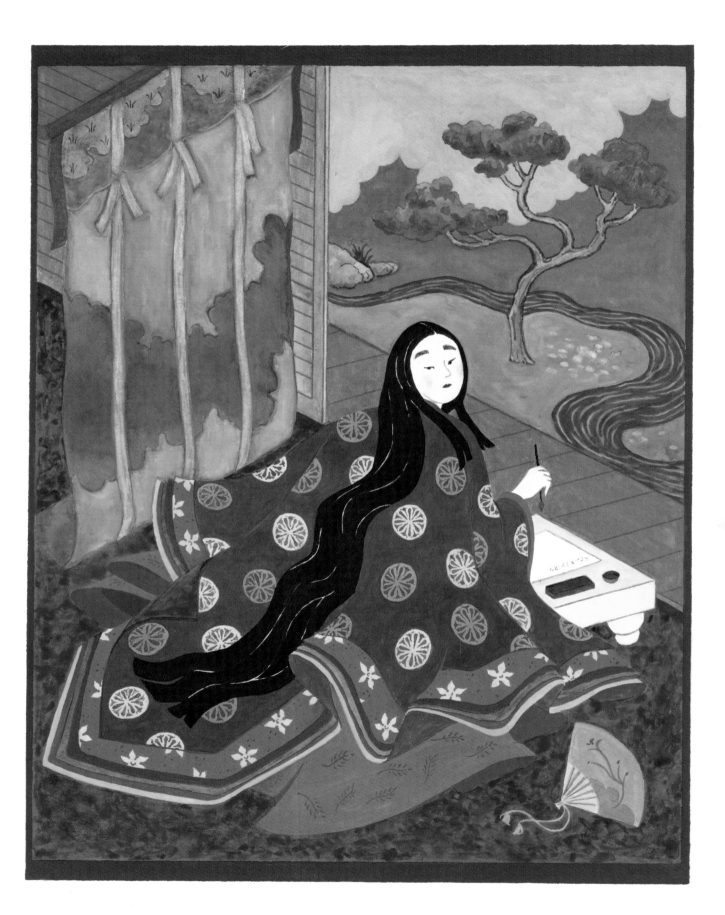

LADY MURASAKI SHIKIBU

[circa 970–unknown]

"The true heart ties fast the lavender knot,
The hue of loyalty"
—from the *Tale of Genji*

It's summer in 1006 in Heian-Kyo (Kyoto), capital of Japan, in the time known as the Heian era. Long, thatch-roofed wooden buildings raised on posts stand inside the Imperial courtyards. Some of them are "compounds," linked together by roofed walkways. One such compound houses the Second Empress. The outer "walls" of her residence are bamboo screens, rolled up today so that the Empress and her maids of honor can look out at her charming enclosed garden. Behind them, sliding screens and gauzy fabric panels provide movable "walls."

With powdered white faces and rouged cheeks, eyebrows plucked off and thicker ones painted high on their foreheads, fashionably blackened teeth, glossy floor-length hair, and layered silk garments, the women might be exotic butterflies. They're listening to a maidservant read from a short scroll "book," part of a story about a prince named Genji. The author, a shy, pretty lady-in-waiting, sits nervously, eyes downcast. The reading over, the Empress praises the new chapter, and the author, known as Murasaki, blushes and bows, modestly hiding her smile behind

23

a decorated sandalwood fan. History knows Lady Murasaki Shikibu not by a given name, which was changeable, but by her father's title (Shikibu) and the name of a heroine in her story, Murasaki (meaning "lavender"). She's been writing it for several years and will continue to add to her *Tale of Genji*, which will become not only the first true novel in history, but also one of the most beautifully and realistically written.

Little is known about Lady Murasaki's life beyond a few dates. She was born in the 970s, into a minor branch of the great Fujiwara clan, whose chief was the all-powerful Fujiwara Michinaga. Although in theory a divine emperor ruled Japan, Michinaga, like his forebears, married his daughters to a series of powerless emperors and filled government posts with his own relatives, including the future Murasaki's scholarly father.

While her father taught his son the "classics," mostly Chinese works, and the complicated court script, also borrowed from China, he taught his daughter "women's writing," a simpler script based on phonetics. But this daughter, not content with what women were allowed to learn, hid behind a screen and eavesdropped on her brother's lessons. When her father discovered how much more she had mastered than her brother, he said that he wished she'd been born a man, since education was "wasted" on a woman. Ironically, it was because they were not allowed to use Chinese-style script that women, not men, developed a truly native Japanese literature. And this particular woman would use her wasted education to write a masterpiece.

The future Murasaki was at least twenty, old for a girl of her rank, when a much older relative married her around 999. People usually married to help improve their family's fortunes rather than for love, and since polygamy was the rule among the Heian nobility, some of his earlier wives were probably still living—and competing for his attentions. Yet perhaps this bride was happy with her husband, because he owned a library of histories, romances, travel memoirs, and diaries.

She had a daughter in 1000 and lost her husband during a plague a year later. The young widow returned to her father's house, probably rarely leaving her dim, curtained living area except for a temple visit or to witness a court parade. At home noble women played board games with their friends or attendants, wrote poetry or diaries, read Buddhist scriptures, or sat for hours, lonely and doing nothing. The future Murasaki used her

lonely hours to write her tale, which eventually covered over seventy-five years. She described the lives and romances of many people, and especially told the story of Genji, the "Shining Prince." Sensitive and refined, he was loyal to the ladies he courted and took care of them long after passion had faded. Genji was an ideal man for whom love was not merely desire but also abiding loyalty—the kind of man Heian women longed for but didn't always get.

She shared her story with friends, and someone in power must have read and liked her story, for around 1005, Fujiwara Michinaga allowed her to join the royal court. She was important to his daughter, the Second Empress, whose rival, the First Empress, also surrounded herself with

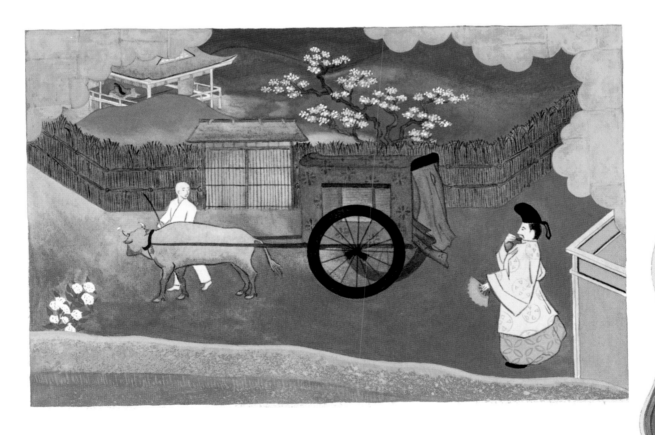

Ever hidden, even while traveling, a lady might encourage a suitor by letting him glimpse her sleeve or hem.

cultured ladies. It was not long before the newcomer had made a name for herself as Lady Murasaki Shikibu, "Lady Lavender."

Today, we can still imagine Murasaki's world through her vivid and accurate writing. In the lovely "Capital of Peace and Tranquility," polite society was guided by three principles: the nonviolence of Buddhism, the "rule of good taste," and tasteful flirting. In other societies, warlike qualities were admired, but not in Heian Japan. Marriageable noblewomen like Murasaki had been central to the Fujiwara clan's rise to power. Its "marriage politics" had worked better than violence, and allowed the rise of a peaceable, cultivated nation. Instead of hunting or training for battle, noblemen played ball games, drank rice wine, and like the women, composed and quoted poetry, wrote graceful calligraphy (seen as a true reflection of personality), and blended the perfect incense. And they fell in love with ladies, half-glimpsed or overheard. Unmarried girls awaited a love poem, perfectly written on just the right paper and folded, sealed, and decorated; or yearned for a secret visit from a would-be lover and possible husband. Married women could be caught in the game, too—Fujiwara Michinaga himself pursued Lady Murasaki, much to her alarm.

Custom, ritual, and duty boxed everyone in. To survive, women had to attract powerful noblemen through their poetry, calligraphy, music, or painting, since they were rarely seen. And, despite their respect for elegance and gentleness, people were still prey to hopeless love, fear, jealousy, and belief in harmful spirits, as well as to illness and early death. Using poetry and images of nature to evoke mood, Lady Murasaki wove all these themes together in her portrait of a beautiful world tinged with sadness. Although Heian Japan was eventually swept away by civil war, thanks to Lady Murasaki its memory still lingers like faint perfume.

Between 1008 and 1010, Murasaki wrote a diary, which is our main source of information about her. Parts of it seem to be missing. Then she fades from view, almost like some ghostly character in her novel. Perhaps she became a Buddhist nun, having given up the pleasures and pains of love. She may have died as early as 1014 or as late as 1032, but no one knows for certain. She could not have guessed that she had set the standard for all future Japanese writing, nor that her tale would rank as one of the greatest novels of all time. But, by being true to feelings and by drawing a portrait of a society as beautiful and fragile as a flower, Lady Murasaki left us a gift matched only by William Shakespeare in England: She shaped a nation's literature.

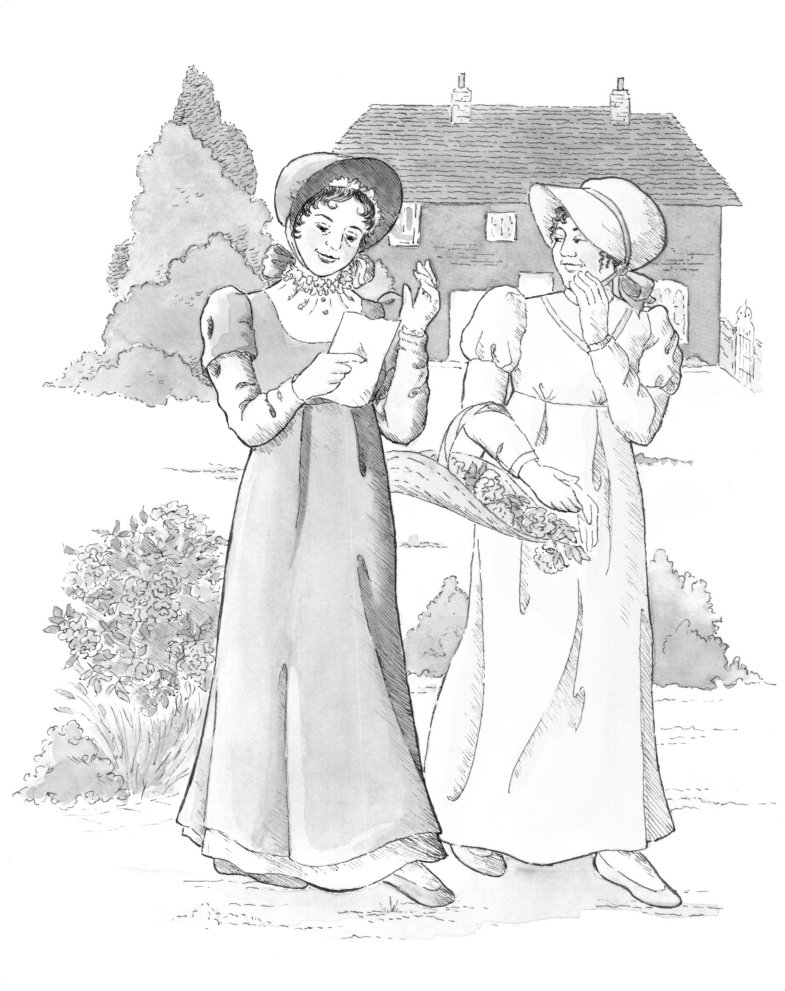

JANE AUSTEN

[1775–1817]

"Anything is to be preferred or endured rather than marrying without Affection."
—from a letter to a niece, 1814

In the winter of 1796, a ball is in progress in a village assembly hall in southern England. Older guests play cards in one room, while in the other the young people are country dancing, much as people line dance nowadays. Defying the gossips who think it's wrong to stay with the same partner all evening, one couple chooses to stay together, since it's their farewell evening. Tomorrow the young man is being sent away by his relatives to prevent the two from falling in love, for Jane Austen has no money.

Next morning, in her little sitting room, Jane, a slender girl with full pink cheeks, dark curly hair, and expressive hazel eyes, pens a letter to her older sister Cassandra. "Imagine to yourself everything most profligate and shocking in the way of dancing and sitting down together," she writes wryly. Over 200 years later her sharp humor still makes us laugh at human folly, both in her letters and in her novels.

Jane was the seventh of eight children. She was born in a country village southwest of London called Steventon, where she lived over half her life. Her family belonged to the gentry, a class sandwiched between the

29

nobility and the "lower orders" (people like tenant farmers, servants, or laborers). Rank was as important in late eighteenth-century England as it was in Heian Japan, and while Jane had rich noble friends, the Austens themselves were not rich, a fact that continually shaped her life.

Jane loved country life. When little, she'd roll down the hill behind the house; when older, she and Cassandra, her sister and best friend, explored country paths beside blooming hedgerows and green meadows. Twice, though, their parents sent them away to girls' schools. The first time, when Jane was only seven, typhus swept through the school, nearly killing them both. A year later, they were at a new school, but when he discovered what a poor education they were getting, Mr. Austen brought his daughters home and taught them himself, with help from his excellent library.

The little girls were glad to be back, especially shy Jane, who was only comfortable around friends. Life at home was full of fun, for the Austens loved to laugh; people made their own entertainment before radio and television were invented. The sisters shared a bedroom and a sitting room with a brown patterned carpet, table and chairs, a bookshelf, and an oval mirror on the wall between two windows. Here they practiced their "accomplishments": Jane wrote, played piano, and sewed, while Cassandra painted watercolors. They also read, danced, took walks, or occasionally went horseback riding. Relatives and friends came for long stays, too, so life was never dull. They put on plays in the barn, or read novels aloud to one another in the evenings around the fireplace. In those days, some people believed that novels corrupted society, but not the Austens.

From her early teens, inspired by the romantic or gothic novels she read (with titles like *Horrid Mysteries*) and by her family's quick wit, Jane began writing wild parodies. For instance, she wrote a history of England, illustrated by Cassandra, satirizing the pompous histories of her age. She also visited distant friends and relations, and wrote home about gossip, the latest fashions, or someone's silly pride in their pigsties. Yet she reserved her witticisms for her family; publicly she became a well-behaved, quiet young lady.

And as she grew up, she began to write more realistically, though she kept her wild sense of humor. In her early twenties, she wrote first versions of three novels that would one day make her famous. Human folly

played a large part in her gentle romances about young women's problems in their search for love, but they always ended happily, with the right man proposing to the heroine.

Jane hoped to wed one day, too, though she was in no hurry to enter the "Marriage Market." She enjoyed balls and parties (held on the full moon for lighting the way home), flirted mildly, and rejected one serious admirer. Yet marriage was almost the only option for "ladies" besides sewing, teaching, or depending on parents or relatives. Just as in Lady Murasaki's day, marriages were often based less on love than survival. As

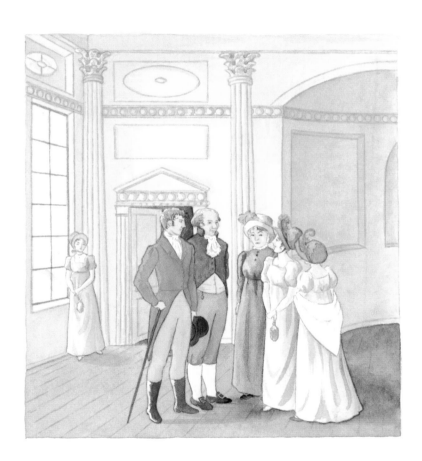

Jane witnessed the "Marriage Market" at work in places like the Pump Room, the social center of Bath. A rich older man had the advantage over a handsome but poor younger man.

soon as they had "come out" from the schoolroom at about seventeen, girls, helped by their matchmaking mothers, looked for husbands of means, while cash-strapped noblemen and penniless younger sons pursued young heiresses. Anyone lacking wealth or rank was at a disadvantage.

In 1801, Mr. Austen retired on half-pay and moved his wife and daughters to the city of Bath, famous since Roman times for its hot springs and now an elegant resort town. Some think Jane was dissatisfied living among well-off neighbors, while she had to practice "vulgar economies." Yet there was another reason to be unhappy. On a holiday at the seaside, Jane and a young clergyman fell in love. He asked to visit her soon, perhaps to propose marriage. Instead, he died suddenly. We know nothing more; to protect Jane's privacy, Cassandra destroyed everything written between 1801 and 1806.

A year later Jane agreed to marry a much younger family friend. She would become wealthy, and at twenty-seven she could expect few other offers, if any. Yet she shocked everyone by changing her mind overnight—an engagement was almost as binding as a wedding. Perhaps she still pined for her dead clergyman, but Jane had also realized that she couldn't marry, even for wealth, where she felt no love. She received another proposal some time later, but again she was not interested.

Although Jane used Bath as a setting in some of her novels, she stopped writing stories while she lived there, perhaps discouraged by the fate of a novel she'd sold to a publisher in 1803. *Northanger Abbey* lay lost in her publisher's desk drawer, and was not published until after her death.

In 1805 Mr. Austen died suddenly, leaving his wife and daughters in poverty. But with help from the Austen brothers, after several moves, the ladies settled into a red brick cottage in the country village of Chawton. Jane spent much of the rest of her life there, teaching and sewing for the poor, or writing letters to friends, artfully folded and sealed. Now an "old maid," she paid visits or hosted nieces and nephews, telling them fairy tales and playing "spillikins" (pick-up sticks) with them, or helping them sail paper boats.

And, at the urging of her brothers and admiring young relatives, she started writing again, not only for fun, but to earn money. She revised her two earliest novels, while starting yet another. This time, they not only reached publication, they were instant successes: *Sense and Sensibility*

came out in 1811, *Pride and Prejudice* in 1813, and *Mansfield Park* in 1814. Ever genteel, Jane wanted no one to know she had written them, so the author was listed as "A Lady." Not even friends knew; whenever visitors arrived, Jane hid her work under her paper blotter. She guarded her privacy so well that, years later, local villagers, unaware that a genius had lived among them, were still wondering why so many people came to see where she had lived.

But Jane was delighted with success: On visits to London to see her publishers, she enjoyed plays, balls, and studying ladies' big bonnets. By 1814, when she wrote *Emma*, it had leaked out that she was the "Lady" who'd written such delightful books. When Jane met the librarian of the Prince of Wales, future king of England, he informed her that the prince was her great fan and wanted her next novel dedicated to him. She didn't respect the prince, a well-known playboy, but dutifully dedicated *Emma* to him.

Jane might have written much more, but strange backaches and weakness slowed her down. By 1816, when she finished her last complete novel, *Persuasion*, her mysterious ailment was draining her life away. She had what is called Addison's disease, but in those days this condition didn't even have a name, much less a cure. By early 1817, she was clearly dying, although she believed she would get better. She even started a new novel to cheer herself up, but never finished it. She died in Cassandra's arms, only forty-one years old.

Today, Jane Austen's books, funny and truthful, are more popular than ever. As in real life, her women characters had few life and marriage choices, were expected to behave perfectly, and faced disgrace if they misbehaved. Men led far freer lives. Jane never publicly challenged this double standard, only insisting that she herself would never settle for a loveless marriage. However, her stories humorously raised many questions that future women authors would ask ever more clearly.

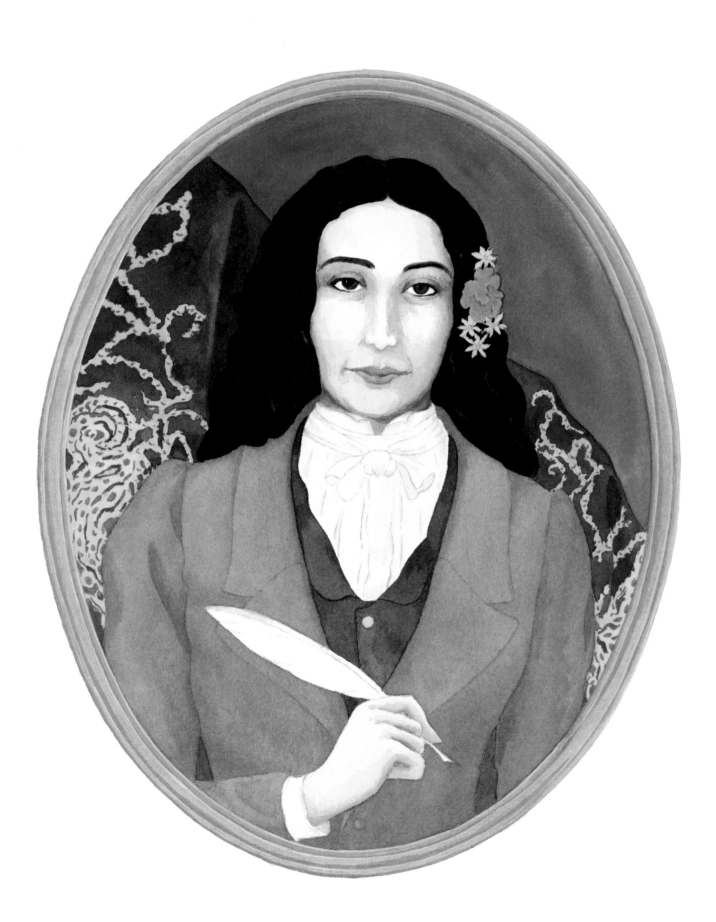

GEORGE SAND

(AURORE DUPIN DUDEVANT)

[1804–1876]

"…he who loves is greater, even if he strays,
than the one who walks undeviating along a cold, lonely path."
—from *Lucrezia Floriani*, translated by Julius Eker

In Paris, one evening in 1831, several young comrades enter a crowded theater. Buying the cheapest tickets, which are for the "pit," they must stand right at the stage's edge to watch the play. Women are not allowed, possibly because the pit is full of poor or rowdy people. The group lets their shortest member, a dark-eyed, cigar-smoking youth, stand in front to see better. After the play is over, they all visit their short friend's lodgings. Once inside, the young fellow throws off his hat, and his long dark hair tumbles free: "He" is a "she"! Her name is Aurore Dudevant. She dresses like a man not to shock but because it costs less than women's clothing— and also allows her freedom to go where women are not allowed. Besides, she's always loved playing "dress-up." One day her costume will become part of her legend: the notorious George Sand, a married woman (with a man's name) who lives independently.

George Sand was the pen name for Aurore Dupin Dudevant, one of the most complex and powerful authors of nineteenth-century Europe, and her life mirrored its many upheavals. Fifteen years before her birth in 1804, France had suffered a bloody revolution. Its idealistic new Republic had replaced a greedy monarchy, only to fall into disorder and then into the grip of an ambitious general, Napoleon Bonaparte. Aurore was born the same year Napoleon became Emperor. He quickly abandoned the

ideals of the Republic—Liberty, Equality, and Brotherhood—making divorce illegal and women virtual slaves of their husbands, and briefly led France into wars of conquest. Aurore would spend a lifetime torn between opposite worlds: not only between Napoleon's laws and Republican ideals but also between her parents' backgrounds. Her father, Maurice Dupin, was descended from kings, but her mother, Sophie, had been a prostitute.

Maurice was an officer in one of Napoleon's conquering armies. Horrified by his marriage, his wealthy mother would have nothing to do with his new family, so they lived in deep poverty in Paris while he was away. Yet Sophie awakened Aurore's imagination and her love for nature. When Aurore was three, her family joined Maurice in Spain where they lived grandly in a royal palace. Left alone much of the time, she played "dress-up" in a tiny uniform like her father's, danced in a little Spanish gown and lace mantilla, or told stories to an abandoned pet rabbit.

In 1808, the Spanish drove the French armies from Spain. Having escaped with almost nothing, Maurice brought his family, now ill and half-starved, to the family estate, Nohant, to show his newborn son to his mother. But the baby died, and only days later Maurice was killed, thrown from his horse. Four-year-old Aurore, too young to understand death, was suddenly heir to Nohant and a fortune. Her hot-tempered mother and strong-willed grandmother competed to possess her, but Madame Dupin won. Sophie left, and Aurore, feeling she had lost both parents, was raised at Nohant.

Although Madame Dupin meant well, she did her utmost to turn Aurore against her mother. Divided in her loyalties, the lonely girl grew up with an eternally aching heart. To comfort herself, she imagined her own "god," Corambè, who was both father and mother to her. And she wrote stories. Sometimes, in order to ride more easily around the estate she would inherit and was learning how to run, Aurore dressed in men's clothes. She loved exploring nature and became friends with the local peasants. Later they would often be heroes in her novels. But her grandmother also made her learn to behave as a lady, even sending her to a convent for three years to complete her education.

Madame Dupin died when Aurore was only seventeen, and Sophie reentered her life—but now she wanted some of her daughter's fortune

*At her country estate, George Sand could relax with her beloved Frédéric Chopin,
and each shared their creative ideas with the other.*

and treated her almost as an enemy. Aurore fled her mother's control by agreeing to marry a young man who promised her a stable life. She was eighteen when she married Casimir Dudevant, and the marriage was a disaster. While she was creative and cared about books and ideas, Casimir preferred hunting, getting drunk, and pursuing other women. Under Napoleonic law, he controlled Nohant and Aurore's fortune, both of which he mismanaged. Even the birth of a son and daughter could not soften the reality: Aurore was imprisoned in a miserable, sometimes violent marriage.

But she possessed the will to escape. She eventually persuaded Casimir to let her leave him for parts of each year, and began moving back and forth between Nohant and Paris, between domestic duties and the world of art, music, and theater, sometimes taking her children with her. Casimir gave her a small allowance from her own fortune when she was in Paris, but she also needed to make a living. Her only skill was writing, so she became a journalist, then a novelist, essayist, and playwright. She adopted the pen name George Sand for a wildly romantic novel, *Indiana*, which brought her instant fame. Based on her own experience as an unhappy wife, it also caused a scandal, since wives were expected to submit silently to their husbands. But it gave voice to feelings that readers, especially women, recognized as their own, and from that point on, Aurore Dudevant became a literary giant.

She took on a whole new life as Madame George Sand, the eccentric author who cared nothing about convention. She wrote over eighty pieces, including some sixty novels (often based on her own life), whose themes were always love: from romantic, to spiritual, to love for humanity. Writing quickly to make money, she rarely revised her work, so today some novels seem sloppily written. Yet she used her confused and difficult life as material to shine into the darkest corners of the human heart. She paved the way for modern novels, using dream images and symbolism, and she lived as dramatically as her own plots. Yet behind the veil of theatrical effect, a lonely girl was still looking for love.

After a series of court battles, she finally won a legal separation from Casimir, but she could never remarry. Yet she could not live without love, so she had love affairs with a series of fellow authors and intellectuals, several of them years younger than she was. Each time, she thought her new

lover would be the man she would love forever, but none of them could fill the aching hole in her heart. Her most famous affair was with the famous composer, Frédéric Chopin, with whom she lived and whom she supported for over eight years.

She also endeared herself to France by championing causes based on the old slogan of Liberty, Equality, and Brotherhood, believing that everyone who faced social or political discrimination needed to be liberated, man and woman alike, whether from the gentry or the peasantry. In her writings she fought unfair marriage laws with the same passion that she fought for women's freedom to love. As a social reformer inspired by Christianity, she witnessed and even indirectly participated in three French uprisings against a series of brutal monarchs, and she used her fame to save several outspoken fellow authors from imprisonment or death for treason.

Ironically, George Sand is today remembered more for her scandalous way of life than for her enormous influence on the form that novels took and the issues they began to deal with. Yet thanks to her, women no longer had to take the subtle route of a Jane Austen. They could speak out boldly.

CHARLOTTE BRONTË

[1816–1855]

"This is an autumn evening, wet and wild....
The wind cannot rest; it hurries sobbing over hills of sullen outline,
colourless with twilight and mist."
—from *Shirley*

I t's 1826. Four English children sit on the floor of their small nursery, while rain beats on the windowpanes. Charlotte Brontë, a tiny girl with fair hair and gray-brown eyes, is ten. Beside her is her brother Branwell, nine. Across from them sit Emily, eight, and Anne, six. They are quietly making up a story together; having lost their mother and older sisters, imagination is their comfort. Charlotte and Branwell sometimes stop to write down or illustrate a scene on paper because they're turning their tales of adventure, politics, and romance into miniature magazines for his wooden soldiers. Each magazine is no more than three inches tall and two inches wide, and the writing, so small that it's hard to read, is printed to look like type.

The Brontës lived in northern England, in a world of harsh winds, few trees, purple heath-covered hills, misty valleys, haze-producing fabric mills, black stone villages, and ghosts walking abroad. Their father was a stormy, often remote Anglican minister; their gentle, quiet mother died when the oldest of her six children was only eight and the youngest was still a baby.

A graveyard in front of their cold, damp stone house was their playground.

After their mother's death, their aunt helped care for them, but for love the children turned to one another: Maria, Elizabeth, and the four younger children, all made quiet by loss. In 1825, Mr. Brontë sent the four oldest girls to a boarding school. From its advertisement, the school sounded excellent, but in reality it was run almost like a prison; worse, it hosted a quiet killer, tuberculosis. Within a year, Maria and Elizabeth were dead. Mr. Brontë sent his younger daughters to another, better, boarding school, where they were treated lovingly, and where Charlotte eventually became a teacher. But early mistreatment and loss had left scars; Charlotte grew up always expecting the worst.

After her older sisters died, Charlotte began acting as mother for the others. Together they dreamed of life beyond the mills and moors of home and of how they would all become famous authors or artists, especially their darling Branwell. When grown, both Charlotte and Branwell sent samples of their writing to famous authors, hoping for encouragement, but Charlotte got none. Warned against choosing an "unfeminine" profession, she had to work as a governess, although she hated having to instruct spoiled, rich children whose parents treated her as though she scarcely existed.

In 1841, the three sisters decided to open their own boarding school to support themselves, since they expected never to marry. Charlotte discounted two previous marriage proposals, believing that no man would truly want an old, dwarfish wife of twenty-five. And her sisters weren't interested in marriage. As part of their plan, the sisters wanted to master a variety of subjects. Leaving Anne at home to look after their father and aunt, Charlotte and Emily returned to school, this time in Brussels, Belgium, at the boarding school of a Monsieur and Madame Heger. It was a difficult change for two country girls, and when their aunt died, they came back home. But Charlotte returned for about a year, first as a student and then as a teacher, always lonely, and hating teaching. And she fell in love with Monsieur Heger, a fact clearer to his wife than to her: Madame treated Charlotte with increasing hostility. Finally, in despair, Charlotte left.

With Charlotte back home, the sisters tried to start their boarding school. In 1844 they printed and distributed a prospectus—and waited in

vain. No one wanted to send their child to school in such an out-of-the-way place. Meanwhile, scandal descended on the Brontës. Branwell had become a tutor for the children in a wealthy family, only to be fired for having an affair with his employer's wife. After that, he could not get steady work, ran up debts, and turned to liquor and then opium to dull his misery. With their brother at home falling into madness and their good name blackened by scandal, the sisters gave up all hope of opening a school.

They were now stuck at home, often ill, and faced with either returning to teaching under the harsh rule of some schoolmaster or wealthy, arrogant family, or with caring for their father and brother—and eventual poverty after their father's death. They decided their duty lay at home. For relief, Charlotte, Emily, and Anne turned to reading books (George

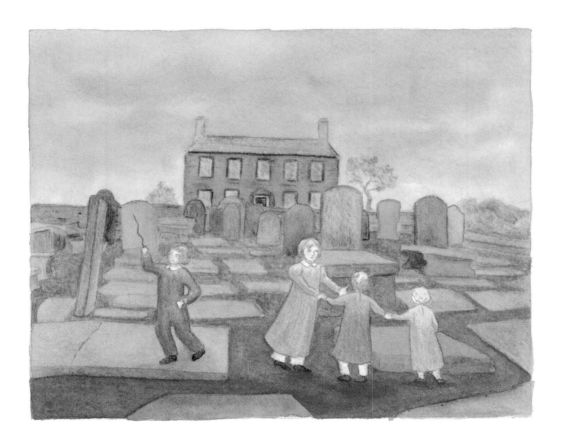

The Brontë children had no friends but each other,
and no playground but the graveyard.

Sand was a favorite) and to their own writing; all three began novels. Each night, while the damp house stole their health, they sat before the parlor fire and wrote, or strolled around the room arm in arm, discussing their stories together.

Then Charlotte discovered some poems Emily had written. Impressed by their quality, she determined that the three sisters should publish a book of poems together. They wanted no one to know that women had written them, so in 1846, under the pseudonyms of Currer, Ellis, and Acton Bell (for Charlotte, Emily, and Anne Brontë), Charlotte self-published a thin volume of poetry. It did not sell.

Never giving up, Charlotte tried to sell the three novels the sisters had written. Emily's novel, *Wuthering Heights*, and Anne's, *Agnes Grey*, found publishers. Charlotte's, *The Professor*, did not, and it was never published in her lifetime. Both *Wuthering Heights* and *Agnes Grey* failed to sell well at first; readers were dismayed at the violent emotion of *Wuthering Heights*, inspired by George Sand, and at the bleakness of *Agnes Grey*.

Charlotte, refusing to give up, wrote a second novel, *Jane Eyre*. This book did find a publisher, and it came out in 1847. As with all her novels, she based its characters and atmosphere on her own life. Because it exposed the dark side of polite society, and because its heroine felt passionate love and hatred, some critics thought *Jane Eyre* was "dangerous" and committed "outrages on decorum." But Charlotte, like her heroine George Sand, had written truthfully, and the book was an instant bestseller. This was a new kind of heroine: a plain girl, orphaned, treated unjustly, and triumphing over trouble and class prejudice to find love. Even today, young readers identify with Jane's outspokenness, dignity, and refusal to give up. Charlotte's career was launched, though to protect her identity as a clergyman's daughter, she kept writing under the name of Currer Bell. Her sister Anne published a second novel, *The Tenant of Wildfell Hall*, and the sisters revived their hopes of prosperity.

Instead, tragedy struck again. In 1848, Branwell died, a shell of their beloved brother. Three months later, tuberculosis claimed Emily—always stubborn, she refused even to see a doctor until hours before her death. And six months later, just before Charlotte's third novel, *Shirley*, was published, quiet Anne also died of tuberculosis, leaving Charlotte alone with her aged father.

Burdened with such sorrow, many people would have despaired completely, but Charlotte's whole life had been a triumph of willpower over suffering. She mourned deeply and never again expected to find pleasure in life, but she had a duty to her aged father and there were still stories to tell. She even rejected two more suitors, unable to imagine that marriage could bring her happiness.

By the time she published her fourth novel, *Villette*, her fans even included Queen Victoria. With fame came prosperity. Charlotte traveled to London and to Edinburgh and to the Lake District (Beatrix Potter's future home), and met other major writers and thinkers of her day, like her hero, William Thackeray. Although painfully shy and conscious of being tiny and plain, she held her own among her new, glamorous friends. She used her fame to get Emily's novel, *Wuthering Heights*, reprinted. Today, both *Jane Eyre* and *Wuthering Heights* are classics. Anne's novels are also still in print.

And Charlotte did find love. One of her father's assistants, Arthur Bell Nicholls, had quietly adored her for years and, in 1854, finally persuaded her to marry him. To her surprise, she was deeply happy with her new husband. Yet, for a final time, tragedy struck. Charlotte had only been married for a few months when she, too, began to waste away, from a combination of severe morning sickness and tuberculosis. She died in 1855, only thirty-nine years old.

Charlotte Brontë had lived her entire life weaving duty to her family with her passion for writing: Her life inspired what she wrote, and writing was her life. Her aim in all she wrote was to show women as human beings with emotions and dreams, and with the right, no matter how humble their lives or plain their looks, to live with dignity and to seek love. It was her great tragedy that her own feelings were most often grief and loneliness, and that just when she found love, she lost her life.

EDITH JONES WHARTON

(EDITH NEWBOLD JONES)

[1862–1937]

*"I could not believe that a girl like myself
could ever write anything worth reading, and my friends
would certainly have agreed with me."*
—from *A Backward Glance*

In a glittering ballroom, the cream of New York society is witnessing the "coming out" of a slim, pretty seventeen-year-old. Her red-gold hair is styled in fashionable ringlets, her gown of pale green brocade and white velvet emphasizes her slenderness, and a family friend, a young man of fashion, has escorted her into the ball. Yet all evening long, one young man after another asks her to dance and she refuses—she's so shy that she can scarcely speak. She'd rather be at home, crouched on the library floor, writing a story or poem on one of the huge pieces of brown wrapping paper that the servants save for her. She doesn't dare ask for real writing paper for her "scribblings." It's 1879, and not even Edith Jones herself guesses that one day she'll be an award-winning author.

While Charlotte Brontë had to overcome isolation and near-poverty in order to write, Edith Newbold Jones had to fight free from a rigid, wealthy society. Her family belonged to a small circle of well-to-do families, all related to each other, who traced their ancestry back to early colonial America. The members of this unofficial aristocracy might do charity work or travel abroad, but mostly they led proper but unimaginative lives and, in Edith's words, thought of authorship "as something between a black art and manual labor." She would grow up feeling crushed by their "standards of heartless correctness," but her novels about New York society

47

would become classics.

When she was only three, her family moved to Europe, where it was less expensive to live. European countries, full of vistas, lovely buildings, gardens, and interesting people, enchanted little Edith and gave her a lifelong love of travel. By the time her parents settled in Paris in 1868, she was already making up realistic stories as she never cared for fantasy. She would walk back and forth, pretending to read them aloud from a book, sometimes holding it upside down. So, to her great delight, her father taught her to read. In 1870, when the Joneses returned to New York, Edith thought New York City was ugly compared to the elegant European cities she had visited. And to her mother's dismay, she preferred reading in her father's huge library to making friends with other society girls.

Spending summers near the fashionable town of Newport, Rhode Island, and winters in New York City, Edith dutifully tried to fit in, playing sports and visiting friends. But inside she felt smothered. In spite of her mother's disapproval, she turned to writing, and by the time she was fourteen, she had finished a funny novelette, including negative reviews of the book she wrote herself. When she was fifteen, a literary journal published one of her poems. But her mother was determined to stop such nonsense, and even "brought her out" a year early, when she was only seventeen, hoping her daughter would soon marry and become a proper society wife.

When Edith was eighteen, the family moved to southern France, hoping its warmth might benefit Mr. Jones' declining health. She was thrilled to see new sights again. Unhappily, her father died, and when she was twenty, the family returned to New York and the same empty, rigid life. Time passed and two romances came to nothing. Finally, in 1885, at the old-maidish age of twenty-three, Edith married a much older man, Edward (Teddy) Wharton. Teddy was easygoing, sociable, and shared some of her interests, so she ignored the whispers about his mad father.

Edith and Teddy settled into a routine of summers in New York and winters in Europe. Yet in between traveling and social engagements, she still wrote. Occasionally she sold poems or a short story, some of which were about people living in poverty. She saw a connection between her life full of rules and theirs of want: Each was a prison. The conflict between what was expected of her and her desire to write led to a nervous breakdown in 1894. With no friends who supported her efforts (not even Teddy), she stopped writing for three years.

In 1897, with her confidence shakily restored by a rest cure at a sanatorium and by the effects of time, she and an architect friend wrote a book together, *The Decoration of Houses*. Still popular today, it explained how to decorate elegantly and simply—the opposite of the cluttered Victorian look that New York society took for granted. And after Edith and Teddy built a home of their own in Lenox, Massachusetts, they could live more simply themselves, with fewer pressures to conform. But a pattern began to appear that eventually caused a deeper and deeper break between the couple: Edith always fell ill in New York City, while Teddy, who liked the world Edith was trying to escape, always fell ill when they were away from it.

She could write more freely in her new home, and in 1902, her historical novel of eighteenth-century Italy, *The Valley of Decision*, became a best-seller. As the years passed, Edith sold novels, short stories, including ghost stories, travel journals, and poems. Although the theme of her fiction was usually love, her ironic, unsentimental plots were often about people trapped by ignorance or convention in a world that stifled their love, their dreams, or their creative natures. Often, as in *The House of Mirth*, they described the complexities and pitfalls of New York society, but one of them, *Ethan Frome*, which became a classic for young readers, was a brooding story set in a remote New England village.

During World War I, Edith Wharton set up hospitals, homes, and businesses for displaced men, women, and children.

49

With each new success, Edith believed in herself more and broke further from pressures to conform to the narrow life of a society matron. The Whartons spent ever more time in Europe, and Edith made friends with other famous authors, such as Henry James, who understood and encouraged her. But Teddy was growing ill, both physically and mentally. He was caught stealing money from her trust fund (almost a million dollars in today's money) and using it on affairs with other women. In an ironic twist worthy of one of her own plots, Edith herself had fallen in love with another man. Ashamed of her own wandering heart, she gave up her own friendship and spent years trying to take care of Teddy. Finally, Edith admitted defeat. In one of the most painful decisions of her life, she divorced him in 1913. She settled in Paris, while he stayed in New York.

When World War I broke out, Edith chose to stay in France and help. She found homes, food, and work for refugees; established orphanages and tuberculosis sanatoriums; and visited war zones to deliver medical supplies. She also raised aid money by becoming a war correspondent for U.S. magazines. In gratitude for her many-sided help, in 1915 the French government inducted her into its Legion of Honor, as did the Belgian government in 1918. But, as modest in her generosity as she was about her writing, she felt she had done nothing special.

After the war, Edith began writing fiction again—some of her best, like *The Custom of the Country*, the tale of a social-climbing woman. In 1921 she received the Pulitzer Prize, America's highest literary award, for *The Age of Innocence*, a story of thwarted love, and in 1923 Yale University awarded her an honorary Doctorate of Letters, both honors being firsts for a woman. In 1927, she was nominated for the Nobel Prize for Literature, the world's highest literary award. Edith wrote an autobiography in 1934, called *A Backward Glance*, in which with her usual modesty she told more about her friends than about herself. She spent the rest of her life writing, traveling, supporting the relief organizations she had founded, and enjoying friends from many countries. In 1937, she had just finished another short story when she died. She had broken through personal as well as social barriers and shown that women everywhere could live rich, full lives by refusing to give up doing what they love.

One World, Many Voices

S tarting in the nineteenth century, women's voices began to swell into a chorus around the world. From protest works to historical fiction to murder mysteries, from poetry to travel journals to award-winning novels, women authors have produced some of the finest works of literature in the modern age. They have used these different genres to explore universal themes: love, death, pain, and joy. Many women have paid particular attention to relationships: How people are going to get along with one another in a shrinking world while saving what is special about their own heritage.

In this section, we'll rediscover some important writers who are less well-known today (there are fashions in authors as well as fashions in clothing), as well as follow the lives and achievements of many currently popular authors. They come from everywhere and have many different stories to tell, but they all have something to share: a passion for every part of life and a passion for the power of words.

ISAK DINESEN

(KAREN DINESEN BLIXEN)

[1885–1962]

"Through all the world there goes one long cry
from the heart of the artist:
Give me leave to do my utmost."
—from a short story, "Babette's Feast," in *Anecdotes of Destiny*

In Denmark the summer sun rises early and sets late, and when the moon sails over the sea, night seems like a pearly dream. On one such moon-drenched night in 1894, nine-year-old Karen Dinesen sits at her bedroom window, spinning out an endless, fantastic adventure tale to her younger sister Elle, while nearby, the sea kisses shore. Elle, however, wants her to stop. Even if it's still light outside, it's late and she wants to sleep. Reluctantly, Karen goes to bed, too. But she's happily caught up in her story and continues to tell it to herself until it blends into dreams.

Twenty-eight years later, Karen lives in an utterly different world. She's now Baroness Blixen, a divorced woman running her own coffee plantation in the Ngong Hills outside Nairobi, Kenya. On this summer's evening, she sits on a leopard skin rug in her living room, her wind-up record player's tinny voice lost in the vast African night. But she's still happily telling stories, this time to a man named Denys Finch-Hatton, the love of her life. All her life Karen will appreciate the underlying unity of things, like the equal beauty of the cool blue air of Denmark and the warm gold of Kenyan sunlight.

Karen Dinesen grew up on a prosperous seaside farm called Rungstedlund. In addition to her parents and four sisters and brothers,

Karen's maternal aunt and grandmother lived with them. All these people were strong-minded and active in political reform movements. Though they fought for women's rights, her mother's people were middle-class, living by unspoken rules about morals and politeness. Her father was the radical black sheep of his conservative, noble family. A disillusioned war hero, he had once lived in self-imposed exile in the American forests, befriended only by a tribe of Chippewa Natives. Because of his past, Karen always felt linked to Native Americans.

Karen was her father's favorite, and he taught her to see no conflict between behaving like a grand lady and having democratic ideals. He took her on walks in the nearby woods or hills, and she learned to feel at one with sun, shadow, soil, sky, and all living things. Tragically, her unhappy father committed suicide when she was ten. For the rest of her life, Karen blamed him for abandoning her and blamed herself for not foreseeing and preventing his death. From that point on she would always expect loss to follow love.

She saw herself as the family black sheep, too. Karen was educated mostly at home—literature, history, geography, and English, but little else. Her mother, grandmother, and aunt expected a future husband to take care of her. Not understanding her dramatic, imaginative nature, they wanted only to make her into a proper young lady. But Karen believed that "Destiny" called her to create great "Art"—what kind she didn't yet know. Since her family and relatives looked to one another for fun, the only outlets for her creativity were the plays and stories she wrote for their entertainment. Though she loved her family, she felt trapped within that small, closed-in world. A talented artist, Karen finally insisted on attending art school as a teenager, but women weren't taken seriously, and she eventually gave up.

She also preferred her flighty, upper-class Dinesen cousins to her mother's sedate middle-class relatives. She loved to dress up in gowns or fancy costumes and to flirt at balls, though she felt stranded at the edge of their brilliant circle. When she fell in love with her second cousin, Hans Blixen-Finecke, he didn't even notice her. So she threw herself into writing: Between 1907 and 1909, she published three short stories. But she still felt no focus to her life.

Finally when she was almost twenty-eight, she gave up on Hans and

Isak Dinesen's coffee farm was a haven for people from many different tribes. She was one of few white people who respected Africans.

agreed to marry his younger brother, Bror, who promised her a life of adventure. They planned to move to the British colony of Kenya, expecting to make a fortune by farming: He counted on his agricultural training and physical strength to make the scheme work, while Karen simply wanted to escape into another world and become a baroness.

In 1914 they settled in Kenya and with loans from their families started a coffee business. Neither knew anything about coffee growing, but worse, from the beginning drought, a too-high altitude, and even international politics made sure they would fail. When World War I broke out, Bror volunteered to serve in Africa, leaving Karen to run the plantation alone. Although the crops often failed, she did have friends: her native employees.

From the time of her arrival, Africa had enchanted her. Karen loved not only the landscape and game animals, which were as magical, wild, and

free as she had always wanted to be, but also its native peoples: the Masai, the Somali, and the Kikuyu. Although she was their employer, and loved being treated like a queen, she also felt a deep respect for people whose ways were alien to her but whose fearlessness she admired. Over the years, villages sprouted up on the farm as natives who had lost their homes looked to her for leadership and protection. Her African friends shared their customs and celebrations, too, while she taught them to read English, settled disagreements, and gave medical help. Such mutual respect created serious differences between her and the other white people she dealt with, mostly British, many of whom regarded Africans as less than human.

Married less than a year, Karen discovered that Bror had given her syphilis. As feared then as AIDS is today, there was no cure for it, and while some, like Bror, recovered on their own, others eventually went mad or died in severe pain. Receiving mercury and arsenic to combat the symptoms, Karen would suffer from heavy metal poisoning all her life, and would often be in pain. But she refused to lose her generosity or sense of humor. Pain became part of her "Destiny"; it sharpened her sensitivity to the world.

In 1918, at war's end, she made friends with Denys Finch-Hatton, a glamorous British pilot. As she and Bror drifted apart, she fell in love with Denys. He was rarely in Kenya, and he never wanted to commit himself only to Karen, even after she and Bror were divorced in 1921. But Karen adored him and the music, books, and art they shared during his rare visits. All during the 1920s, while the farm slowly failed, her loyalty to Denys and to her African employees kept her going—as did her escapes into painting and writing. Finally, in 1931, she had to sell the plantation to a land developer. She arranged for her people to stay together, but with great difficulty—the British authorities felt no sympathy for a "native lover."

She was packing up to leave when the news came: Denys' plane had crashed. He was dead.

Returning to Rungstedlund, Karen was at first too numb with loss to do anything. Finally, she returned to writing to deal with her pain. She completed a collection of spellbinding short stories called *Seven Gothic Tales*, set not in Africa but in an imaginary European past. Written in English, the language she had spoken in Kenya, they sounded almost as if an ancient Norse bard had spoken through their author. But short stories were

thought to have no market, and several publishers rejected them. Finally, they were published in 1934 in the United States and England under the pen name Isak Dinesen. This name became part of her new identity, along with dressing elegantly and keeping stylishly thin. In 1937 she published a memoir of her life in Kenya called *Out of Africa*, also written in English. A fascinating story of adventure, humor, hardship, and sorrow, it was also beautifully and hauntingly written.

Over the next thirty years, Isak Dinesen/Karen Blixen published more collections of gracefully strange short stories in both Danish and English. Most were jewel-like fables, set in a timeless past where people might turn into birds or become unlikely heroes. Still immensely popular, they appeal to our desire for courage and mystery. She also authored another memoir, *Shadows on the Grass*, in addition to writing essays and speaking on Danish radio. During World War II, Nazi Germany occupied Denmark, and German troops occupied Rungstedlund, which had become her home again. Defiant, she helped hide Jews being smuggled to safety in Sweden. As well, she wrote and smuggled out a book of short stories, *Winter's Tales*, that were so popular in the United States that copies were issued to servicemen to read in the trenches—a relief from the fear and death around them.

Over time, Karen Blixen grew into a legendary literary figure. Twice nominated for the Nobel Prize for Literature, she was almost as well known for her hypnotic personality as for her wonderful storytelling. She enjoyed having her picture taken, once in a Pierrot (French clown) costume. Frequently in pain and vain about her looks, she grew dangerously thin, insisting she could digest only oysters, grapes, and champagne. Young authors formed a kind of court around her, and when she visited the United States in 1959, she was treated almost like royalty. Even in old age, Karen never lost her charm; one admirer made sure she received one red rose every day, no matter where she was, until the day she died. Her legacy lies in how she honored the otherness of real-life people—and the otherness of imagination.

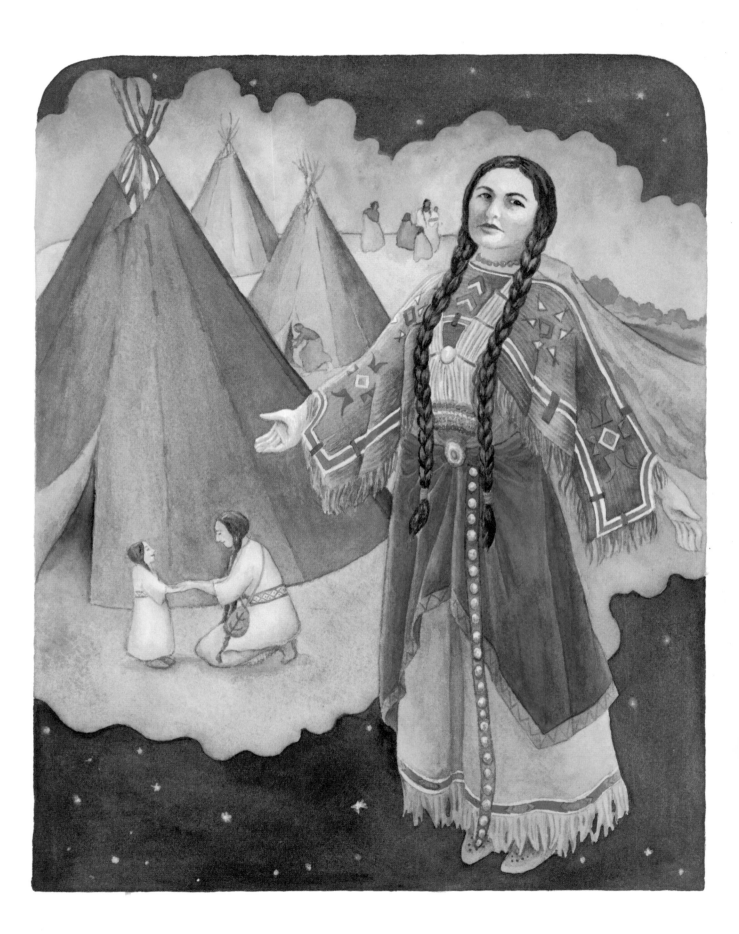

ZITKALA-ŠA

(GERTRUDE SIMMONS BONNIN)

[1876–1938]

"I seemed to hang in the heart of chaos,
beyond the touch or voice of human aid."
—from *American Indian Stories*

On an autumn evening in 1881, a bitter wind sweeps across the Yankton Sioux Reservation in South Dakota, slapping against a circle of tipis (tepees) set on a bluff overlooking the Missouri River. Inside one, warmed by the fire, a little girl with braided black hair snuggles into her mother's lap and listens to the elders of her village share their old stories and legends. Through storytelling Gertrude Simmons is learning her people's history and values. She especially loves the stories about Iktomi, the spider-like trickster who forever tries to cheat others to gain what he wants, but ends up trapped in his own web of lies. One day, she'll help to preserve these stories before they're lost forever.

During the nineteenth century, across America the government forced Native Americans onto reservations, sometimes far from their original territories. Thrust onto the least fertile lands, Gertrude's people were expected to give up their semi-nomadic, sharing ways and become individual farmers like the white settlers, including the Ingalls family, who were moving onto their ancient homelands. The Bureau of Indian Affairs controlled their lives through its agents, many of whom were dishonest and abusive to Native Americans. By the time Gertrude was born, the old way of life was disappearing; even kinship ties were breaking up.

Gertrude never met her white father, who had deserted her mother before she was born. The youngest of nine children, she grew up almost as an only child because, when she was two, her one older brother remaining at home was forced to enter one of the white people's "residen-

tial" (boarding) schools far from the reservation. If he hadn't gone, Mrs. Simmons would have lost half the monthly rations the government doled out to Native Americans.

Gertrude learned traditional skills from her mother, like harvesting wild roots, berries, and seeds, or decorating her deerskin dresses and moccasins with intricate beadwork and porcupine quills. Running and playing with other little girls, she imitated the gracious ways her mother had taught her, secure in the love and respect of the elders. Her mother also warned her not to trust white people's tricky promises.

Nonetheless, at the age of eight Gertrude entered White's Manual Labor Institute, a Quaker missionary school for Native American children far away in Indiana. She had pleaded to go, lured by promises of a trip on the "iron horse" and of many apple trees. But she soon felt whites had indeed tricked her. When she arrived at the school they took away her embroidered clothes, forcibly chopped off her long braids (only done among her people if one was a coward or in mourning), and gave her thin clothing and hard shoes.

"Indian schools" were designed to "kill the Indian" in Native American children and save them from their "worthless" culture. Working and studying long hours, Gertrude was taught that white ways were best. She learned English and how to live like a white American, but not much about academic subjects, since "Indians" were thought to be less intelligent than whites. She lost friends to European diseases like tuberculosis, smallpox, and even measles. She could be punished physically, which was unthinkable among her people but common in nineteenth-century schools. And she was forbidden her traditional faith, since Christian mission schools like White's also wanted to save souls. Though as lonely and afraid as the other children, at first she did fight back in small ways, like the time she was forced to mash turnips as a punishment. She mashed them so hard that she broke the bowl!

But many of Gertrude's teachers were kind and helped her follow her interests. She eventually got used to school and especially loved European-style music, becoming a top student and talented storyteller, actor, and musician. During the eleven years of her schooling, Gertrude was only home twice. By the time she graduated from White's, she had almost lost her connection to her early way of life. In 1895 at her graduation ceremonies, she spoke not about Native American issues but about women's

rights, so impressing one of the women in the audience that she paid for Gertrude to attend college.

Against her mother's wishes, Gertrude did go to college, one more break with her heritage. And, despite her acute loneliness, she excelled. Winning her school speech contest with a speech about the mistreatment of her people, she went to the state competition—not just the only Native American but also the only woman there. During her speech, rival students unfurled a banner crudely picturing a Native American woman and the word "squaw." Though she received second prize, the hurt remained.

In 1897, Gertrude fell ill and had to leave college. After recovering, she began teaching at Carlisle Indian Industrial School, a famous "Indian" school in Pennsylvania. She was shocked at the brutal way the white teachers treated their Native American students, far worse than at White's. And returning home for the first time in six years to make amends with her mother, she found the reservation in crisis. Through another government land grab, white people were now farming the best reservation lands.

Torn between two worlds and belonging to neither, Zitkala-Ša found comfort in playing her violin.

61

Returning to Carlisle, Gertrude began to feel that there, too, whites were stealing from Native Americans—stealing their heritage. Whites seemed more and more like greedy, tricky Iktomi to her.

In 1899 she studied voice and violin at the Boston Conservatory of Music on scholarship, and even performed with the Carlisle Industrial School band at the Paris Exposition of 1900. But wherever she went in white society, it was clear that, despite her achievements and the kindness of her patrons, people still looked down on her. She felt angry at having lost home and family only to end up fitting in nowhere. And she began to feel that Native American values were as good as, if not better than, white values. Gertrude decided that if she could not comfortably follow the old ways herself, she could still bring honor to them. She would fight for her people's rights and culture, using white people's weapons—written words. And, like Iktomi, they would be caught in their own web, because she would show how whites had violated their own values of Christian love by mistreating her people.

Adopting a pen name to prevent risking her job at Carlisle, she became Zitkala-Ša (meaning Red Bird—perhaps symbolizing her desire to fly away from her Americanized self). Reproducing the rhythm of the traditional tales, she wrote about the happiness of her early childhood, the dislocation of her school years, and the injustices her people had endured on the reservation. Three of her memoirs were printed in a major magazine in 1900, and in 1901 she published a book, *Old Indian Legends*, based on the tales she had learned as a child. Because of their gentle style, easy even for children to read, white people could enjoy them—but buried in the soft words was strong criticism for what had been done to her and others like her.

In 1902, Zitkala-Ša married Raymond Bonnin, a man from her own reservation. He shared her ambition to right the wrongs done to Native American people everywhere. For several years they lived on a Ute reservation in Utah, where he worked as a government clerk while quietly helping to fight another land grab.

Running a home and raising their son, Zitkala-Ša missed her music and writing. Once, in 1913, she and a fellow musician worked together on an opera, *The Sun Dance*, based on her people's traditions. Using authentic music, costumes, and dance, it was a huge hit locally, and it was performed as far away as New York City. The only opera ever written by a Native American, sadly it is almost forgotten today.

Zitkala-Ša's energies turned increasingly toward politics. She joined the Society of American Indians in 1913 (a pan-Native self-help organization), becoming its secretary in 1916. In 1917 she and Raymond moved to Washington, D.C., where they tirelessly lobbied for Native American rights. Zitkala-Ša cleverly used her knowledge of white viewpoints: When facing a doubting Congressional committee, she was Mrs. Raymond Bonnin and wore American-style clothing, but she was Zitkala-Ša dressed in Native American attire when appealing to the sympathies of women's groups. White women often supported Native American causes; one famous author, Helen Hunt Jackson, had written an expose in 1883 called *A Century of Dishonor*, which had led to government reforms.

In 1921 Zitkala-Ša published another book, *American Indian Stories*, a collection of traditional tales plus the short pieces she had written in 1900. But she mostly traveled, gathering evidence to use when lobbying in Washington. Over the years, the Bonnins helped Native people in many ways. They exposed a racket of legalized robbery of tribal bands in Oklahoma. Through lawsuits they forced the government to pay money it owed to Native Americans for land. And they won financial and health benefits due to Native American veterans of World War I. They campaigned for United States citizenship for Native Americans (granted only in 1924) and for the abolition of the corrupt Bureau of Indian Affairs. Trying to unite Native Americans politically, the Bonnins also founded the National Council of American Indians.

Although important new legal reforms eventually came out of the Bonnins' efforts, Zitkala-Ša died in 1938, exhausted and discouraged. She had used white people's ways to fight their injustice, but that struggle was far from over—it continues today. What she did not foresee was that white people would slowly begin to appreciate her people's values: how Native Americans favored helping one another over grabbing more for oneself alone; or the importance of treating children with dignity. Perhaps some day not only will Native Americans' struggle for justice be resolved, but also, through the efforts of people like Zitkala-Ša, there will be mutual understanding and respect so that no one need be lost between two worlds.

AGATHA CHRISTIE

(Agatha Miller / Lady Agatha Mallowan)

[1890–1976]

"I have sometimes been wildly despairing, acutely miserable,
racked with sorrow, but through it all
I still know quite certainly that just to be alive is a grand thing."
—from the introduction to *An Autobiography*

In 1916 the Great War is raging across Europe. In southern England, a tall, slim young woman wanders alone upon an isolated hill, talking to herself while birds wheel and cry overhead. She's like a character in a dark mystery story, but Agatha Christie is actually on holiday, working out dialogue for her first detective novel. She's inspired, not by thoughts of bloodshed, but by her love for puzzles, as well as her familiarity with poisons, gained in her job at a hospital pharmacy. *The Mysterious Affair at Styles* will be so successful that she'll write seventy-eight more novels in the next sixty years, plus short stories and hit plays. Agatha Christie will become not only the most popular author of the twentieth century, but the most popular woman writer ever. Over a billion copies of her books will be published in English, and another billion in other languages.

Born years after her sister and brother, Agatha Miller was a beloved "afterthought." Her family lived comfortably on her American father's shrinking inheritance in Torquay, a resort town in England. With few friends, Agatha happily invented playmates, like "The Kittens," with whom she had adventures in the large wooded garden behind her home.

Rather than send her to school, her mother and father gave Agatha lessons at home. She taught herself to read at the age of four but never quite

65

mastered spelling. Though she wrote stories for fun and enjoyed word puzzles, secret codes, and riddles, she preferred singing and piano playing, hoping to become a famous musician someday.

When Agatha was eleven, her father died suddenly. She and her mother, miserable without him, clung together for support and companionship. Most of their wealth was gone, too. Agatha grew up feeling responsible for her mother's welfare.

When Agatha was twenty, Mrs. Miller couldn't afford to give her daughter the grand "coming out" that she'd given her first daughter, so they briefly visited Cairo, Egypt, where it was inexpensive, home to many English people, and the perfect place for quiet Agatha to modestly come out into society. She loved going to dances five times a week and did gain confidence. Back in Torquay, having given up on a musical career as she fell apart if she had to perform in public, she was ready to meet her "Fate," as girls said of their future husbands.

After several light-hearted romances, in 1912 she was swept off her feet by Archie Christie, a handsome pilot in the newly formed air force, but they were too poor to marry right away. When World War I broke out, Archie was among the first to be sent to war. Agatha volunteered at the hospital in Torquay, where she helped care for wounded and dying soldiers. On Archie's first leave late in 1914, they hurriedly married—and he left again. They saw each other only rarely in the next four years. Agatha got a job at the dispensary and learned to depend on herself. For escape, she wrote stories and tried to sell them to publishers. All were rejected.

When she finished *The Mysterious Affair at Styles*, she sent it to several publishers, and all but one rejected it. The last publisher didn't respond, but by then it was 1918, the war was over, Archie was back and had found work in London, and they were expecting a baby. She forgot all about the novel. So in 1919, Agatha was amazed when that same publisher not only bought it but wanted her next five books as well.

But her main interest was Archie. In 1921 he quit his job in London to join a trade mission around the world. Agatha went, too. They visited South Africa (learning to surf, then nearly getting caught in a revolution), saw Australia and New Zealand, took a holiday in Hawaii (more surfing), and traveled across Canada.

Back at home, after some hard times, Archie found another good job in

London. The Christies bought a lovely country home and spent weekends together—until Archie discovered golf and began disappearing every weekend. Agatha tried to understand, although she had little to do beyond raising their daughter Rosalind, writing books, and overeating. She missed her increasingly frail mother, too. She had especially written her second novel to save her childhood home from being sold off.

By 1926, she was a well-established author. Her main hero, dapper Hercule Poirot, a retired Belgian detective, was famous for using his "little gray cells" to solve murder cases. But early that summer, a real death occurred: her mother's. Agatha fell into a deep depression. She forgot to eat and sometimes couldn't remember her name. At summer's end, Archie suddenly announced that he had fallen in love with someone else. He wanted a divorce.

Agatha spent the next few months in shock and despair. In early December she disappeared for eleven days. It was national news: Her car was found halfway down a hill; there was a huge manhunt; and the press speculated about possible murder—or thought it was a publicity stunt after she was found at a hotel under an assumed name. Actually, she was suffering from a form of amnesia. Hounded by the press, trying to regain her memory through psychotherapy, and obligated to finish another book, Agatha refused to explain her disappearance. Always a private person, for the rest of her life she would avoid publicity by pretending to be boring and dimwitted—just the opposite of glamorous, publicity-loving Isak Dinesen.

Divorced from Archie and depending on royalties to support Rosalind and herself, she slowly rebuilt her life over the next few years. She introduced a sharp-eyed elderly amateur detective, Miss Marple, whose instinct for evil made her as popular as Hercule Poirot. And she sometimes wrote spy thrillers for a change of pace. In 1928, Agatha also began to write more serious novels under the pen name Mary Westmacott, keeping her authorship a closely guarded secret. One, a heart-breaking novel called *Unfinished Portrait*, is a thinly veiled autobiography.

In 1929, on a whim, Agatha traveled to the Near East. While visiting the archaeological excavation of Ur in Iraq where a once-famous poet-priestess named Enheduanna had lived, she became friends with a young archaeologist, Max Mallowan. When Agatha returned home, he went as well. Soon after, he proposed to her. Although she loved him, she refused

While helping Max solve archaeological puzzles on his digs, Agatha Christie came up with ideas for mysteries set in the Middle East.

at first—after all, he was only twenty-six, and she was an overweight woman of forty. But he persisted, they married, and they truly did live happily ever after. From 1930 on, Agatha sometimes helped Max on important sites throughout the Middle East and wrote more novels, adding "Oriental" backgrounds to some of them. They would both be honored for their careers: He was knighted, and she was made a Dame of the Empire.

Agatha became known as the "Queen of Crime," the "Duchess of Death," the "Mistress of Murder." Her fans included heads of state, intellectuals, ordinary working people, teenagers, and senior citizens. She had already written several successful plays when *The Mousetrap* was first per-

formed in 1952. It outdid them all. In her lifetime, it became the longest running play ever. Almost fifty years later, it still plays to sold-out audiences.

Having spent decades protecting her privacy, Agatha also wrote *An Autobiography*, to be published after her death. Written to her readers as if they were old friends, she gladly shared her memories—except one: What exactly happened when she disappeared in 1926.

Many critics have analyzed Agatha's "low-brow" popularity, noting that there's more humor than gore in her novels. Also, her stories are elaborate puzzles, with all the clues present but hidden behind false leads. People love trying to guess "whodunnit." And she used standard-seeming characters to fool her readers; for example, an innocent-seeming girl might be the murderer instead of the sinister man in black. Agatha Christie changed with the times, too. Her first novels were set in an ideal England with servants and people of leisure, and even included casual racism; but when appliances replaced servants, young women worked for a living, and racism had been exposed as poisonous, her novels reflected those changes. Today, people young and old enjoy her as much as they did decades ago, because everyone loves a mystery.

ZORA NEALE HURSTON

[1891–1960]

"I am all wrong in this vengeful world. I will to love."
—from *Dust Tracks on a Road*

It's 1901, a hot, muggy Saturday afternoon in the all-black town of Eatonville, Florida. A sprightly girl of ten, done with her errand at the general store, stops to listen to the men sitting around its porch. They are swapping "lies," as they call them—tall tales, proverbs, and jokes about Brer Fox and Sis Cat, or the former slave, John, who always outwits his former "Massa." How Zora loves their treasure trove of funny sayings and colorful stories! One day she'll make them famous through her writing.

Zora Neale Hurston's imagination, as vivid as Agatha Christie's, was shaped by an utterly different background. She was born in 1891 but, ever a storyteller, always gave different birth dates ranging from 1898 to 1910. Zora grew up in Eatonville's tightly knit community, thinking it was the center of the world. As a child, she made up stories for dolls she invented from doorknobs, bars of soap, and cornhusks—store-bought ones didn't inspire her. Once she climbed to the top of a tree in her yard and, seeing the distant horizon, dreamed about traveling there on a white horse to examine its edge.

Her father was a Baptist preacher. They didn't get along—he thought she was too uppity, bound for trouble with white folks—but her mother advised her children to "jump at 'de sun." So Zora shone in school. She especially loved Norse and Greek myths—as inventive as the "lies" she so enjoyed.

When her mother died in 1904, regular schooling came to an end. Zora briefly attended a private school in Jacksonville, Florida, but her father stopped paying for her schooling, and she had to do housecleaning for the school in order to finish the year. Back at home, she was miserable and angry. Her father had remarried, and she hated her stepmother. For the next few years, she would often live with friends and relatives, sometimes working as a maid, sometimes trying to finish school.

When she was about twenty-four, she became wardrobe girl for a white theater troupe that was traveling across the South. The actors befriended her and taught her about formal drama and classical music, while she fascinated them with her colorful language ("I had the map of Dixie on my tongue."). While she enjoyed traveling, she was hurt by racism—like being excluded from all-white hotels.

In 1917, the troupe disbanded in Baltimore, Maryland. There Zora returned to school part-time while continuing to work. When she was twenty-eight, a proud high school graduate, she enrolled part-time at Howard University, a famous all-black college. She joined its literary club, publishing her first short story in 1921, and more stories in the next three years. Her teachers, recognizing her talent, encouraged her to move to New York City to join an artistic movement in Harlem, the part of the city where many black artists lived.

In 1925, Zora was swept into the center of New York's "Harlem Renaissance": a blossoming of visual arts, writing, drama, and music. White people would "safari" to what they saw as the "jungle" of Harlem to mingle with blacks at jazz clubs and parties of "literati." Zora soon realized that while these people enjoyed its vitality, they thought black creativity was crude, arising only from centuries of enslavement, and therefore inferior by nature. They didn't understand that it had dignity, beauty, and richness in its own right. Black people often didn't respect their own heritage, either, abandoning it in favor of white values and lifestyle. For over two years, Zora used her stories to reveal to both whites

and blacks the love she felt for her own roots. As a prize-winning author, she made herself the center of attention wherever she went, with her bright clothes, hats, jewelry, and her vivid, hilarious stories.

Many of the white people Zora met helped black artists financially, yet looked down on them, just as Zitkala-Ša's patrons had done. Nonetheless, Zora accepted one woman's offer of a full scholarship at another famous school, Barnard College, and Zora became its only black student. A world-famous anthropologist, Franz Boas, taught there. Recognizing that Zora's colorful language reflected her heritage, he inspired her to collect oral traditions that were in danger of being lost.

Believing she had a mission to promote understanding of the black traditions she loved, Zora began a double career, as a collector of folklore in the South and as a writer, where she used that lore in her stories. She made her first collecting trip south in 1927 after graduating from Barnard, but it failed. Her Barnard "airs" made her an outsider to black people,

In order to collect folklore, Zora joined the life of the communities she visited, from listening to people swapping "lies" to playing games with children.

and no one would talk to her. After that, she decided to do things her own way by blending in with the people she wanted to interview. With financial support from a white patron who wished to be unnamed, whom she called Godmother, she tried again.

Over several trips, from Eatonville to Florida sawmill camps to New Orleans, Zora recorded many ways of life, as well as "lies," children's rhymes, proverbs, songs, and sermons. At the sawmill camp, people mistrusted her nice clothes and car, and she was accepted only after claiming she was hiding from a rich criminal boyfriend. In New Orleans, she underwent secret initiation ceremonies (including becoming a blood brother to a rattlesnake) in order to study "hoodoo" (related to voodoo)—folk cures and curses, many of African origin. She also visited the Bahamas, surviving a scary hurricane.

But Zora had troubles, too. Her marriage in 1928 soon failed because her husband wanted her to give up her career. In 1929, when she and a poet friend, Langston Hughes, tried to co-write a musical comedy, *Mule Bone*, their friendship broke up when Zora, believing he was stealing her ideas, tried to take credit for their combined work. She also often suffered from ill health. And until 1931 Godmother had complete control of Zora's research, keeping her from publishing it as she wished—in stories and performances.

During the 1930s and into the 1940s, Zora, like others during the Great Depression, survived almost hand-to-mouth, writing articles, plays, and short stories; putting on musical events that showcased black talent; helping other folklore collectors gather material; and teaching at various colleges.

In 1933 a publisher admired one of her stories and asked for a novel. She quickly wrote *Jonah's Gourd Vine*, a tragic story based loosely on her father and his lady loves. It was so successful that her publisher agreed to publish her folklore collection, *Mules and Men*, in 1935. A delight to read, it was not a "scientific" study but a celebration of several different black traditions.

In 1936, supported by an important grant of money, Zora took another folklore collecting visit to Jamaica and Haiti. Out of that trip came *Tell My Horse*, which described her discoveries about voodoo.

Zora also wrote more fiction. Her masterpiece novel, *Their Eyes Were Watching God*, was based on her own experience of trying to become an independent black woman free to love whom she chose. *Moses, Man of the*

Mountain told the Biblical story as if it were black people escaping slavery, led by a great African hoodoo man. She was often criticized by other black writers for not writing enough about black suffering, but she felt that she was not "tragically colored" and that her interest was in sharing her heritage from the point-of-view of love rather than anger. Her last published novel, *Seraph on the Suwanee*, was about a white woman struggling to find love and respect—her attempt to show that some issues are universal.

Zora also published an autobiography in 1942, *Dust Tracks on a Road*. It received an award for its positive effect on race relations. At this time she was the most-published black woman in the United States. But Zora's work began to slip in quality, and publishers rejected several of her novels. She also began to take unpopular positions in the black community, supporting conservative political candidates and even segregation, since it had worked well for her in all-black Eatonville. By the time *Seraph on the Suwanee* came out in 1948, her career was in decline.

Worse, that same year, she was thrown in jail, accused by a mentally ill ten-year-old boy of molesting him. She was able to prove right away that his charges were false, but the bad publicity, especially from black newspapers, hurt her so deeply that she thought about suicide.

Her career never recovered, although she continued to write until her death. Her health declined, a second marriage failed, she often had to work at low-paying jobs, and eventually she entered a county welfare home, where she died in 1960. But Zora's spirit never flagged. And she was the inspiration for a whole new generation of black women authors, led by one of today's most prominent writers, Alice Walker. As well, Zora's love for her heritage has left behind a treasure for all Americans, both in her books and in her folklore collections.

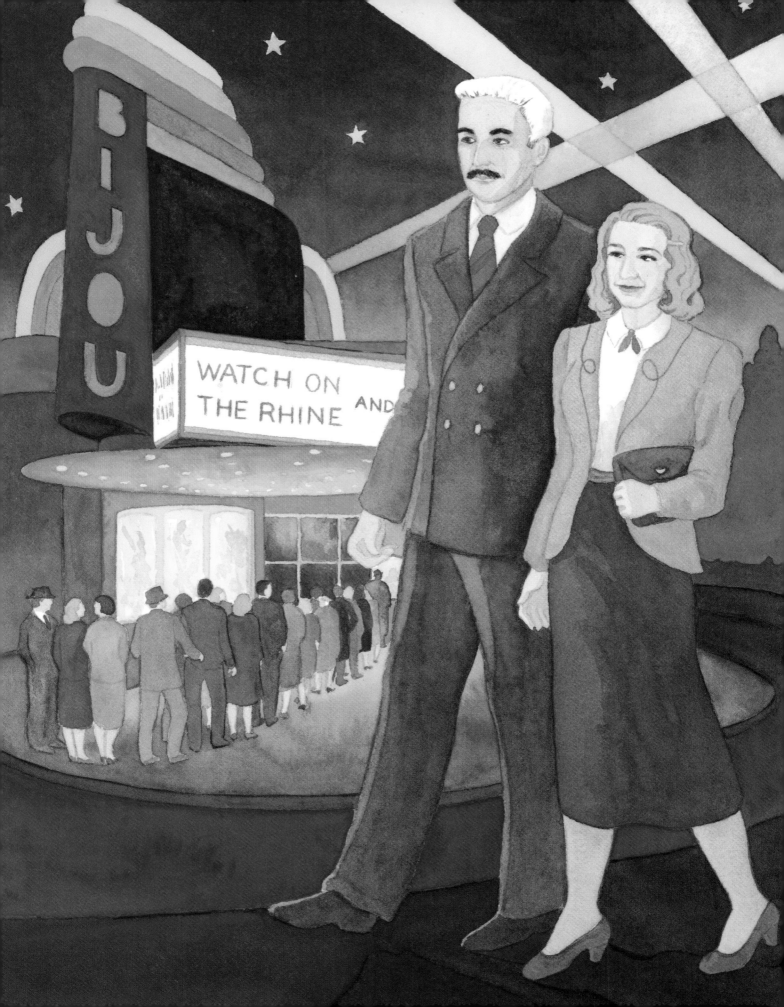

LILLIAN HELLMAN

[1905–1984]

"I blow a stage to pieces without knowing it."
—from *Pentimento*, a memoir

It's the spring of 1952, in the huge Caucus Room of the Congress in Washington, D.C. Members of the House Un-American Activities Committee (HUAC) look down from a high podium at a petite red-blond, brown-eyed woman in her late forties seated at a table next to her lawyer. Reporters occupy nearby chairs, while onlookers sit behind the woman. Dressed elegantly in a black hat and brown and black checked silk dress, Lillian Hellman clutches a handkerchief as committee members fire questions at her. She is both frightened and angry because, in their hunt to expose Communist Party members, HUAC acts as both judge and jury—a power they're becoming famous for abusing. If she refuses to name other suspects, which is what the committee really wants, she can be sent to prison for contempt of Congress. Yet if she pleads the Fifth Amendment, which allows people not to testify against themselves, she won't have to accuse other people but will herself fall under suspicion of being a Communist.

Trying to avoid this double trap, she has written a letter stating that she's glad to speak about herself freely but that "...to hurt innocent people...in order to save myself is...indecent and dishonorable. I cannot and will not cut my conscience to fit this year's fashions." When by

*Terrified and knowing she would be blacklisted, Lillian Hellman nonetheless
stood up to the HUAC in their public hearings.*

chance the committee allows it to be read into the records, she escapes
their power: If she pleads the Fifth Amendment now, it will not seem to
be to protect herself but to protect innocent people. The HUAC unhap-
pily dismisses her. The next day newspapers praise her for being one of a
handful of people who have refused to be frightened by what are now
called the "witch hunts" of the McCarthy era (named after their founder,
Senator Joseph McCarthy).

Born in 1905 to well-to-do Jewish parents, Lillian Hellman grew up
going back and forth between two different worlds and never quite feeling
at home anywhere. Half the year, when her father was not traveling on
business, the Hellmans lived in Lillian's birthplace, New Orleans. She
often hid in the large fig tree on their property, skipping school and read-
ing books. She was so far ahead of her classmates that her teachers didn't
care. A segregated city, New Orleans was also where she first learned,
from her black nanny, to rage against mistreatment of black people, the

kind Zora Neale Hurston was facing in her travels with the touring company. Eventually Lillian would turn her rage on all injustice.

The other half of the year she and her mother lived in New York City, where the public schools were more demanding, and Lillian was always behind. Also, enraged by her mother's wealthy family, whose members were always trying to make more money and get more power over others, she felt guilty about enjoying the comfortable life their money gave her. The only thing she enjoyed there was performing in school plays.

A college dropout, at nineteen she had already talked her way into a clerical job at a major publishing house and become part of the wild-living "Roaring Twenties" generation. She soon married a promising young playwright, Alfred Krober, and published a few short stories, giving up in disgust when she decided they sounded too "lady writer" (a term used by some male authors to put down women authors). She wanted to write tougher fiction.

After the Great Depression struck in 1929, the thirties became a time of labor disputes, violence, and despair for many people. The Krobers were lucky to find work in Hollywood, where Lillian read and wrote short reports on new movie scripts. She hated her lowly job but it taught her how to write for movies and for the stage, media that directly suited her talents. And in Hollywood she met the love of her life, famous mystery writer Dashiell Hammett. By 1932, Lillian had divorced Krober, though they stayed lifelong friends, and had begun living with "Dash," in an off-and-on relationship for the next thirty years.

Dash, much older than "Lil," was self-contained, independent, and a little odd, but spirited Lillian was up to the challenge. They shared a simple belief that rich, selfish people were using the rest of humanity, and that all of society had to change. During the Depression, millions of people were out of work around the world, and many intellectuals admired the ideals of communism—that wealth should be shared equally.

Dash inspired Lillian to write plays, sometimes suggesting plots to her and always being brutally honest about the quality of her writing. Sometimes she rewrote entire plays as many as eleven times before he approved. Her first drama, *The Children's Hour*, was performed in 1934. A story of the destruction of two women's lives because people believed one child's lie, it was a huge hit, nearly winning the Pulitzer Prize. And it set the pat-

tern for all her plays. She became a master of tightly plotted, "well-made" plays; witty, emotional, and hard-hitting, they "blew the stage apart"—just the kind of toughness she'd been seeking. Over the years, Lillian would write eight more fiery dramas, usually about corruption and injustice.

Her plays were not always successful—her second, *Days to Come*, flopped, leaving Lillian afraid she might never write a good play again. But with encouragement from Dash, she kept writing and produced more big hits. Sometimes using her own family history, she created believable characters and dialogue that still ring true. In fact, some relatives were so angry over her most famous play, *The Little Foxes*, that they threatened to sue her.

With her royalties she bought an estate and made it into a working farm, where she and Dash hosted their friends, raised lambs and bred poodles for sale, grew tomatoes and asparagus to sell, and wrote for both stage and screen. Lillian became Hollywood's highest paid screenwriter. She always reflected her times: As Nazism arose in Europe, she wrote about fascism, and *Watch on the Rhine*, like many of her plays, was made into a popular movie.

Lillian's life was as controversial as her plays. She helped screenwriters form a union, enabling them to go on strike (a radical move in those days); observed the Spanish Civil War and reported on it as an anti-fascist; worked for civil rights in the United States; and visited the Communist Soviet Union. Ironically, at the very time Lillian was flirting with Communist ideals, Russia's dictator, Josef Stalin, was violently "purging" his country of millions of innocent people suspected of being "anti-revolutionary." Though she heard rumors of these murders, she refused to believe that real Communists could be so brutal.

After World War II, a "Red Scare" swept across the United States: fear that Communists had infiltrated all of society and that democracy would be overthrown. Senator Joseph McCarthy, whose true motive was personal publicity, led an American "purge," jailing many innocent people, as well as destroying their careers and reputations. Famous people from Hollywood were targets because in the early 1930s, a handful were known to have studied communism and an even smaller number had become Communist Party members. Dash, aging and ailing, went to prison for six months for refusing to cooperate with HUAC's "investigations." Lillian was next in line. Although she was not jailed, after 1952 she and Dash

were "blacklisted" (denied employment) in Hollywood. They lost their large incomes and were forced to sell her farm.

Lillian survived by working at a department store, by writing plays that were based on novels or foreign dramas, and by editing the works of fellow authors. After several years, her original plays—both new and revivals—appeared once again, but Lillian had lost her enthusiasm for the theater. She also lost her beloved Dash to cancer in 1960. It was time to move on.

She began a new career, teaching creative writing at universities like Harvard and Yale, as well as writing for women's magazines. Lillian also began a series of memoirs: *An Unfinished Woman*, which received the famous National Book Award in 1969, and *Pentimento*, a series of portraits of friends. One of the portraits was made into a major movie, *Julia*. In it, a childhood friend, Julia, who was fighting fascism, enlisted Lillian to smuggle bribe money into Nazi Germany to free political prisoners. The story ended with Julia's tragic death. It became Lillian's most famous—and infamous—work. The third book, *Scoundrel Time*, recounted the McCarthy era from her point of view.

All three books were best-sellers, and made Lillian into a heroine to liberals of the sixties and seventies, but *Scoundrel Time* angered people who felt that she wrote as if she had been the only person to resist the HUAC. After all, other people had also risked jail when they refused to "name" others.

More controversy followed. In 1980, Lillian sued a fellow author for slander when the woman called her a liar during a television interview. As the case progressed, it came out that the Julia story might be totally untrue. Lillian died before the case was decided, and it never became clear whether Julia was even a real person—if not, Lillian couldn't have smuggled money for her. Had idealistic Lillian not told the truth just to make herself look heroic? Her last memoir, an examination of the pitfalls of memory, was called *Maybe*. Was that a clue?

Lillian Hellman died with her reputation in question. She valued truth and justice so much—would she lie? Or did she care more about writing a great story than about telling the exact truth? We'll never know for certain—only that she left a treasury of dramas that force their audiences to ask hard questions about their own values.

ELIZABETH BISHOP

[1911–1979]

*"…all my life I have lived…just running along the edges
of different countries and continents, 'looking for something.'"*
—from a letter to a friend, 1976

I t's February 1960, a steamy summer in Brazil. A boat laden with passengers, cargo, and animals glides down the dark water of the Amazon River, passing green jungle and occasional villages. A petite middle-aged woman with gray eyes and wild gray hair leans on the railing and remembers another river, far away in Nova Scotia, Canada, that ran near the woods and village of her early childhood. With time and distance, she can finally face her old memories, with their strange mixture of menace and enchantment.

An only child, Elizabeth Bishop was born in Boston, Massachusetts. Her wealthy father had died when she was only eight months old and her grieving mother had suffered a mental breakdown. With her mother in and out of hospitals, Elizabeth never received the steady love a small child needs. Her parents had roots in the Canadian Maritimes, so little Elizabeth was often shunted between the Bishop home in Boston and her maternal grandparents' home in Great Village, Nova Scotia. Early in life, she began to feel homeless, although in 1915 her mother tried to settle with her among their family in Great Village.

83

Mrs. Bishop was permanently hospitalized in 1916, and Elizabeth never saw her again. Although her grandparents were kind to her, no one ever spoke about her mother once she was gone or gave Elizabeth sympathy and comfort. As small children often do, she thought that her mother's strange behavior and disappearance were somehow her fault. She learned to avoid the loneliness, sorrow, and self-blame that she felt by noticing and wondering about everything around her.

She loved Great Village, and she lost herself in the magic of woods, meadows, farm animals, great red tidal flats, wooden houses, summer flowers, and winter snows. She sang hymns with her family in the evenings, enjoying the rhymes as much as the music. Unfortunately, she also developed chronic bronchitis, a lung disease that permanently weakened her health.

In 1917 her father's wealthy parents insisted on moving Elizabeth to their home in Boston where they expected her to grow up into a proper young lady instead of a barefoot country girl. Already in fragile health, within nine months she also developed asthma, skin rashes, and severe allergies. Her grandparents gave up and sent her to live with her mother's sister in Boston, who allowed her to visit her Great Village relatives in the summers. Elizabeth believed that her gentle, kindly aunt had saved her life. She grew up feeling more Canadian than American—although she never felt that she truly belonged anywhere.

Because she was ill so frequently, Elizabeth often missed school, but her aunt gave her wonderful books to read. By age fourteen, finally healthy enough to attend school and catch up on other subjects, she was far ahead of everyone else in her love and understanding of literature, especially poetry, which had a remarkable way of expressing feelings in just a few words. In her own poems and in journals full of ideas, notes, and observations, she found an outlet for her loneliness and alienation.

In school she soon made a name for herself as a poet of genius. Although Elizabeth's quiet wit won her friends, people never knew how lonely and empty she felt inside, how she longed for a home like theirs. At exclusive Vassar College, she often spent holidays alone in her dormitory or as an afterthought guest of one of her teachers or friends. She also began to drink too much in college, visiting illegal bars with friends during the

Although often lonely, Elizabeth had good friends like the famous poet
Marianne Moore, who promoted her young friend's career.

Prohibition era. Alcohol temporarily numbed the emptiness she felt inside, but it couldn't quench her emotional thirst.

In 1934, her last year of college, her mother died. Shortly after that, Elizabeth made friends with a famous poet, Marianne Moore, who became a kind of substitute parent. Miss Moore believed in Elizabeth, gave advice about her poems, introduced her to publishers, successfully recommended her for grants and prizes, and shaped her already-promising career.

Yet Marianne Moore's friendship could not fill Elizabeth's empty heart. After graduation, asthma and her sense of belonging nowhere drove her to move and travel often over the next few years in a quest both for life experience and a healthy climate. She would eventually visit Europe, Morocco, Mexico, Haiti, Brazil, and the Galapagos Islands, and revisit Nova Scotia. Her poems were often about seeking a place to belong.

While her girlfriends were falling in love and marrying, Elizabeth felt herself to be a flop with men. Worse, in 1936 an old boyfriend proposed marriage to her. When she declined, he sent her a postcard saying, "Go to hell, Elizabeth" and committed suicide. For the rest of her life, she would blame herself for his death—and be afraid of getting close to men.

Her way of coping with such painful events was to turn them into poetry, short stories, and short memoirs. Since she had taught herself to

observe carefully ever since she was little, she could draw out feelings by vividly describing parts of the world that we usually overlook. A perfectionist, Elizabeth agonized over every poem she wrote, looking as long as twenty-five years for the perfect word or phrase that would express life's strangeness and beauty.

For a few years, when not traveling she divided her time between Florida and New York City, publishing occasional poems that added to her growing reputation, but dogged by ill health, depression, and alcoholism. She was part of a generation of authors and artists, including Lillian Hellman and Dashiell Hammett, who drank too heavily. While some thought drinking was glamorous or helpful to their creativity, many people's lives were ruined by it. During Elizabeth's lifetime, many of the people she loved best became mentally ill, alcoholic, or suicidal.

Despite her personal difficulties, Elizabeth never gave up, writing poems that were universally praised for their perfection. From 1945 on she won more prizes and grants. In 1946 she published her first book of poems, *North and South,* and in 1949 she became poetry consultant to the Library of Congress. Yet no honors could fill the void in her life; she never felt that she deserved them.

In late 1951 she began a steamship voyage, intending to circle the world. In Brazil, she visited an upper-class Brazilian woman, Lota de Soares, whom she had once met in New York. When Elizabeth suffered a serious allergy attack and was hospitalized, her new friend looked after her. Drawn in by Lota's caring nature, Elizabeth decided to stay. Lota became her intimate friend, sharing her homes in the mountains and in Rio de Janeiro for some fifteen years, ten of them happy. Elizabeth was able to write without pressure, seek help for her alcoholism, get new treatment for her asthma, and begin writing poems and prose about her difficult childhood.

Despite her absence from the United States, honors still poured in. Her second book of collected poems, *North and South—A Cold Spring,* received the 1955 Pulitzer Prize for Poetry. Over the next ten years she often received fellowships and grants that allowed her to travel, as well as a few surprise awards. But by then, Elizabeth's life in Brazil had totally unraveled. The government had been overthrown in a military coup, the economy was collapsing, and Lota, who had worked for the government, was becoming increasingly unstable. In 1966 Elizabeth took a job teaching at

Washington State University to bring in money, but she could scarcely stand the stress of the job, and her drinking spun out of control again.

After Elizabeth returned to Brazil, Lota was hospitalized for a nervous breakdown, and Elizabeth moved to New York to await her friend's recovery, hoping that Lota would join her and that they could begin a new life in the United States together. Instead, the same day that Lota arrived in New York, she took an overdose of tranquilizers and died. Again, Elizabeth blamed herself for not foreseeing and preventing her friend's desperate action.

Fleeing New York, she lived in San Francisco for a year, then tried Brazil again. But there was nothing left there for her, and she returned to the United States, where she began teaching creative writing at Harvard University, while suffering more painful bouts of asthma, alcoholism, and repeated injuries from falling while drunk. Despite all these miseries, Elizabeth's books continued to draw many honors. Between 1968 and 1979 she received honorary degrees from seven major universities (enough to paper a wall, she claimed). She received more awards than any other woman poet in American history.

Elizabeth Bishop died suddenly and painlessly in 1979, leaving a small but brilliant collection of writings that continue to gather popularity with the passing years. Despite her illnesses, her alcoholism, and what she saw as her failures in relationships, she never wavered in her commitment to her art. She will be remembered not for any "failures," but for her genius at saying everything in just a few words.

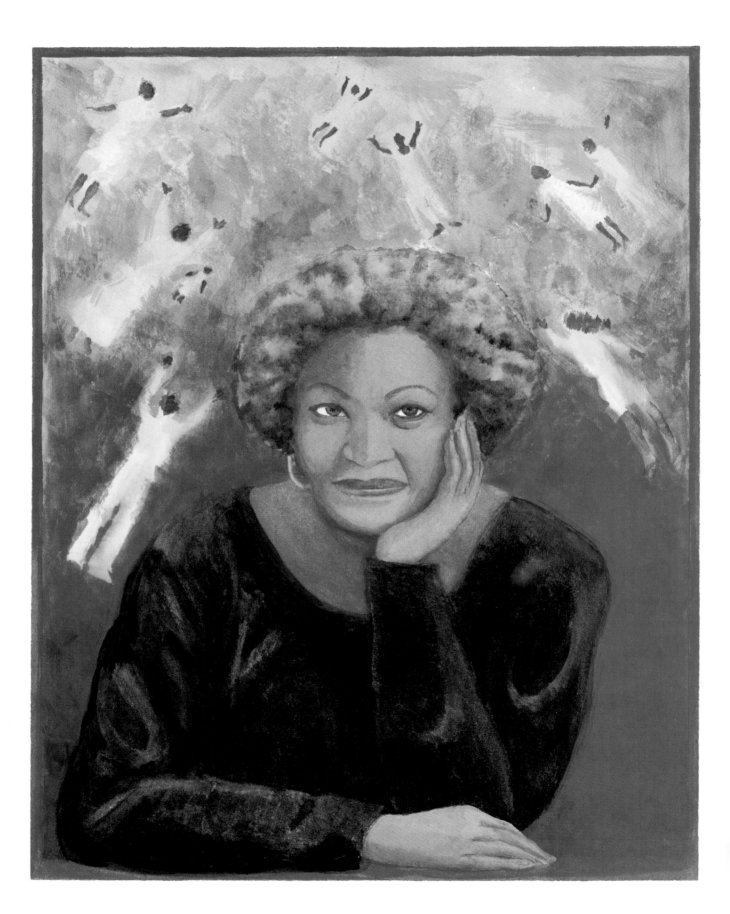

TONI MORRISON

(CHLOE ANTHONY WOFFORD)

[1931–present]

"Race is the least important piece of information
we have about another person."
—from an internet interview at Time.com, 1988

While a snowstorm batters the house, Chloe Morrison, nicknamed Toni, works late into the night on her first novel, about a black girl who wishes for blue eyes. Hurting from a recent divorce and having just moved to Syracuse, New York, to take a new job, she'll remember 1966 as one of the loneliest years of her life. Expecting to transfer to New York City soon, she sees little reason to make temporary friendships here. However, her two little sons, Harold and Slade, delight her, and she loves writing, which she began merely as a way of filling time. She finally stops, stretches, slips into the boys' room to tenderly adjust their blankets, and flicks off the last lights in the house.

Toni wasn't lonely where she grew up. In Lorain, Ohio, a small steel-mill town located on the shores of Lake Erie, neighbors looked out for one another. Born Chloe Anthony Wofford, she was surrounded by a supportive family, and she had white as well as black friends and neighbors. Many of them had recently immigrated from Europe and Mexico seeking a better way of life—just as her grandparents had escaped the brutal racism of the segregated South. Nonetheless, racism lay below the surface in Lorain, too: There was an unofficial black section in the movie theater, and the beach at the lake was strictly off-limits to blacks.

Chloe didn't allow such limits to affect her, surrounded as she was by a loving family—parents, siblings, grandparents, aunts, and uncles—who shared songs and laughter, traditional folklore, and even ghost stories. One of her favorite folktales was how, before they had been enslaved, black people could fly. Chloe's grandparents had been born into slavery, and even when freed they had been cheated and abused by white people. Her father hated whites, believing they were naturally cruel, and her spirited mother stood up for her rights if they were violated. But her mother also taught Chloe to keep an open mind toward all people, to value learning, and to "fly" to whatever heights she chose in life.

In first grade, she was the only black child in her class—and the only one who could already read. Teachers counted on the bright little girl to help newly arrived classmates who didn't yet speak English. But by high school, Chloe realized there was little connection between her schooling and her own heritage; history class, for instance, was about only white people. Even worse, her teachers, using pseudo-science, taught that blacks were less intelligent than whites, although she herself was one of the smartest kids in class! And though she loved reading (Jane Austen was a favorite), there was so little literature by and about black people. It didn't occur to her to become a writer then, however. She dreamed of flying across a stage as a ballerina, a dream that passed.

Graduating from high school with honors, Chloe was the first in her family to attend college: all-black Howard University (Zora Neale Hurston's alma mater). She soon shortened her middle name and became Toni since fellow students mispronounced Chloe. Toni majored in English, but was again disappointed to find that her college teachers also ignored black writers. However, she enjoyed acting in plays and even toured across the South with the college repertory company. There she saw for herself how vicious racism could be.

After Howard, Toni earned a master's degree at Cornell University, and since 1955 has been teaching English composition at various famous universities, including both Howard and Cornell. In 1958, she married an architect, Harold Morrison. How far she had flown from her small-town background, and how promising the future must have seemed! Unfortunately, the marriage was unhappy. By 1962, now a new mother, Toni felt both lonely and frustrated, so she joined a writer's group for fun.

Although she enjoyed the companionship of fellow writers, and even dashed off a short story that would be the basis for her first novel, *The Bluest Eye*, she didn't yet see herself as an author. She and Harold divorced in 1965, while she was expecting their second child, and, with emotional support from her family, she took a job as a textbook editor at a publishing house in Syracuse. Then she began to spend long nights reshaping that short story into a novel.

Meanwhile, a powerful civil rights movement had begun sweeping the nation. Black people were demanding the respect as well as the rights long overdue them. Martin Luther King, Jr. had been leading protest marches, and people had challenged segregation laws in court, and white racists had beaten, shot, and lynched blacks, and bombed their homes and churches. People across the United States, black and white alike, were outraged. Although her life revolved around Harold Jr., Slade, and work, after mov-

As a young woman, Toni found so few books by or about African-American women that she felt as if her experience was falling through the cracks of literature.

ing to New York City in 1967, Toni did participate in the civil rights movement by promoting talented young black authors and by writing articles that made her a well-known spokesperson for black pride and anger.

Nonetheless, she felt there was too little fiction written by black women. As well, many black authors seemed more interested in explaining their experience to white people than in reaching black readers. Toni wanted to create a fictional world that would be familiar to black readers and appealing to anyone else, just as Jane Austen had done in her novels. And she'd already written a novel that *was* about growing up female, black, and powerless. *The Bluest Eye*, published in 1970, set the tone for all Toni Morrison's future novels by marching right into difficult, bleak, and even violent situations, looking them square in the eye, and revealing both shocking and wondrous qualities in them.

Her next novel, *Sula*, about friendship between two women who share a painful secret, was nominated for a National Book Award. Toni was suddenly pulled in several directions at once: parenting, editing, teaching, and writing, but she rose to the challenge. Seeing how whites automatically regarded her growing boys as likely criminals simply because of their skin color, she wrote *Song of Solomon*, about young men trying to find meaningful lives beyond those allowed by whites. In 1977 it received two major awards, and it led to Toni's appointment to the National Council on the Arts. Her next book, *Tar Baby*, explored complex relationships between and among blacks and whites. She also wrote a play, *Dreaming Emmet*, based on a true incident: Suspected of whistling at a white woman, a black youth had been murdered by white men.

In 1983, her reputation established, Toni Morrison retired from editing to teach and write. Her vivid writing transformed painful topics into near-poetry. She drew upon personal memory, folklore, and the supernatural, looking back to the stories she had learned as a child, to explore different black points of view, some angry, some violent, some full of beauty. She turned white stereotypes upside down, making readers think for themselves and come to their own conclusions about her characters and their behavior. And she also overturned the traditional rules of fiction, choosing instead to create her worlds through unusual plotting, imagery, and rhythm. In every novel, she experimented with these elements, intending not just to record black experience but also to help create a new and spe-

cial African-American literature. And her writing inspired a new generation of black women to write and to fly above the boundaries set around them by white society.

But Toni Morrison became a major author of the twentieth century (some say the best) with what at first seems to be a ghost story, called *Beloved*. Toni had previously avoided writing directly about slavery because it was such a horrific subject, but in *Beloved* she created not only place and time (just after the Civil War) but also human suffering. Like all great novels, it made the personal universal, and it challenged readers to question everything they thought they knew about right and wrong. When *Beloved* was passed over for the National Book Award in 1988, major black authors were enraged. When shortly thereafter it received the Pulitzer Prize, some white authors protested that she only won it because of the outcry over the Book Award, rather than because *Beloved* deserved to win!

In 1989 she began teaching at Princeton University, the first black woman to have an endowed chair at an Ivy League university. But her greatest tribute came in 1993, when she received the Nobel Prize in Literature, the first African American to receive this honor. Again, some critics claimed that she received it only because she was a black woman and the prize committee was trying to be politically correct, implying that her works didn't have true literary merit. In response, she quipped that had a white man won, no one would claim that he'd done so because of his race.

Since *Beloved*, Toni Morrison has moved her novels forward in time to explore other aspects of black experience: *Jazz*, set during the New York Harlem Renaissance, and *Paradise*, set in an all-black town in the early 1970s. Both take on difficult themes like jealousy, greed, and racism. She is currently working on another novel.

Now in her early seventies, Toni Morrison has said that she no longer feels angry. After so many years of challenging racism, she says she only feels sad that so little has changed. But to read her novels is to be transformed. By making us aware of the many kinds of black experience, she invites us to fly beyond the boundaries of prejudice. And her books remind us that if we fail to do so, we will all remain enslaved by it.

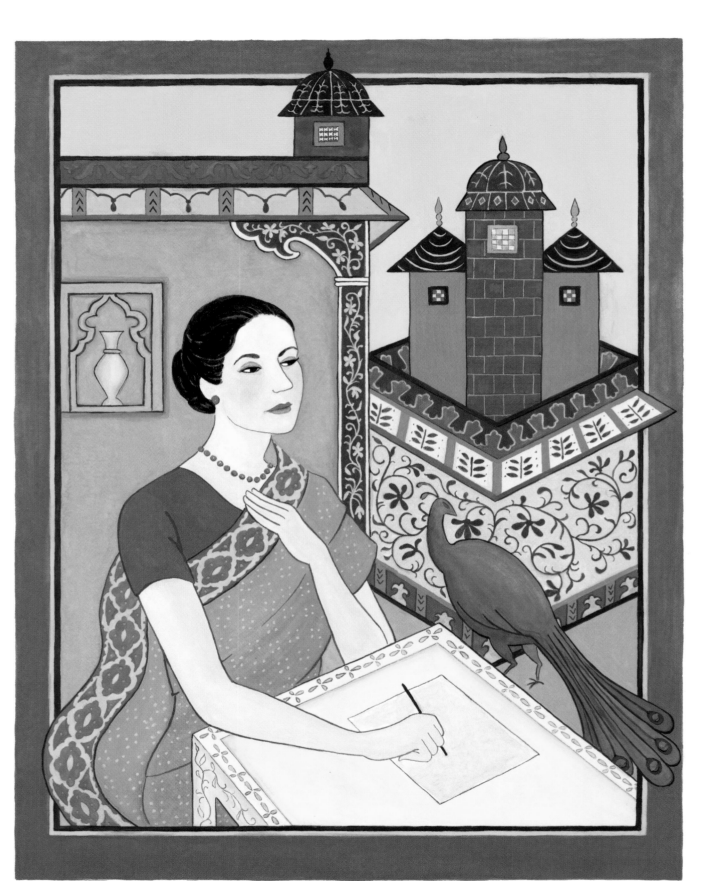

ANITA DESAI

(ANITA MAZUMDAR)

[1937–present]

"India is…a territory both physical and emotional…that I inhabit.
Solitude has been a condition I've often described….
Also the battle between the inner and the outer self, the need to bring
about some synchronicity in order to avoid a conflict that crushes."
—from a written interview with the author, 2001

Late one summer afternoon in quiet Old Delhi, a pretty, dark-eyed girl of ten sits reading in a shady corner of a huge garden. Around her, purple bougainvillea colors the air; roses scent it. Koel birds swoop and dive, calling to one another, while bright green parrots flit among the branches of papaya, fig, mulberry, and silver oak trees. The heat is fierce, but Anita Mazumdar is so absorbed in her book that she doesn't notice. Not until her mother calls her in does she look up, a story of her own already forming in her mind. Later today she'll write and illustrate it, then sew it into a homemade book cover. She glances over the thick garden walls as she walks toward the family home, and the reality of India in 1947 intrudes. Even from here, Anita can see smudges of smoke against the sky where New Delhi lies, and where Hindus and Muslims are virtually at war with each other.

It's a time of great change for India. It will soon separate into two countries, Hindu India and Muslim Pakistan, and refugees will stream across both borders, many having lost both family and possessions. Meanwhile, many of Anita's Muslim friends and neighbors are quietly disappearing, leaving houses silent and empty. She will never forget those terrible days.

Born in 1937 in the foothills of the Himalayas, where her German mother and Indian father were staying to avoid the summer heat of the plains, Anita grew up in Old Delhi, speaking German at home, Hindi to

neighbors, and English at the convent school she attended. English was the one language that was spoken all across India, and Anita connected it with her great love: books. As soon as she could read at around age six, and before she knew how to spell, she knew that her destiny lay in literature. Her supportive family regarded her as "The Writer," especially after several of her stories were published in children's magazines.

Growing up exposed to both European and Indian culture—for instance, her mother spoke German but dressed in traditional Indian saris, and the family read European books like *Wuthering Heights* and listened to European music—Anita was fascinated and troubled by the world she saw around her. The friction between Hindus and Muslims seemed endless. And under the impact of British rule, ancient traditions were crumbling and taking new shapes. For instance, Indian women had customarily married young, borne many children, and devoted their lives to husband and family. Now they could also get an education and have careers of their own—if they were willing to abandon the security of the old ways. And there was so much for Anita to observe and absorb in her immediate world, from the noise, dust, smells, and colors of sleepy Old Delhi to the orderliness of school routines.

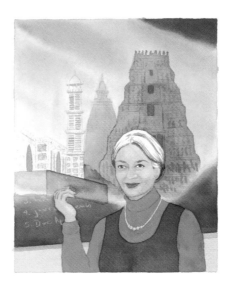

In addition to bringing her Indian heritage to life in her books, Anita Desai now also joins East and West in the classroom, as a professor of fiction writing.

She also realized that her own family was different (marriage between Germans and Indians was rare), which set her apart from her schoolmates. She felt comfortable only in "the rich and intense world of a book" and, as a writer who knew no fellow writers, she felt utterly alone. Anita grew into a quiet, self-contained teenager.

However, when she was seventeen, she and a neighbor, a young mother named Ruth Prawer Jhabvala, became friends for life. Ruth was a successful novelist leading an outwardly ordinary existence, and she not only encouraged Anita to write but also, having herself successfully combined marriage, family, and career, became a role model for her young friend.

Anita had just completed an honors degree in English literature at Delhi University when she married Ashvin Desai, a businessman. While Ashvin supported her desire to write, within the first eleven years of marriage they had four children. During that time of demands from little ones, seeking to balance her roles of wife, mother, and author, Anita wrote only during the school year when she was alone and saved summers entirely for her family. Ironically, while her own life was quiet, she often wrote about emotional conflict and physical violence. Her stories arose directly from the challenges that India, with its long and rich history, has faced in trying to mold a new nation from Hindu, Muslim, and British influences. Writing about realistic issues was new for a woman author in India; women usually wrote romances.

At first Anita wrote only short stories, but in 1963 she produced her first novel, *Cry, The Peacock*, about a wife who feels so smothered that she turns to violence. It was published not in India but in England, as were the novels and short stories that followed. As a result, she is as famous in Britain, the United States, Canada, and other English-speaking countries as she is in her homeland. Using patterns of speech that reflect Indian speech and worldview, she has established a reputation as one of the great "Anglo-Indian" authors—a new generation of Indian writers who write in English. Her colorful, personal stories show Indians not as exotic and unapproachable but as ordinary people facing universal problems, just as Toni Morrison's do. She has been so successful in creating a bridge between Eastern and Western cultures that, in addition to receiving many literary honors from her home country, she has even received an award from her government for promoting Indo-American relations. And she

97

was appointed to the American Academy of Arts and Letters even though she was an Indian citizen.

Probing her characters' inner lives and enriching her stories with symbolic detail—screeching birds, decaying houses, mountains made ugly by litter—many of Anita Desai's earlier novels dealt with the conflict women feel in trying to balance the demands of the outer world with their own needs. As her writing evolved, Anita Desai explored themes of loneliness, inner conflict, and self-discovery within a rapidly changing India.

Although her plots are sometimes stark and even violent, her rich prose, seasoned by her dry wit, has been compared to poetry. Nor is all of her work about inner conflict; she has also written several children's stories, one of which, *The Village by the Sea*, received an award from a major British publication. In 1978 her novel *Fire on the Mountain* received two important awards. In addition, three of her novels have been shortlisted for the Booker Prize, England's highest literary award: in 1980 for *Clear Light of Day*, in 1984 for *In Custody*, and in 2000 for her most recent novel, *Fasting, Feasting*, a haunting story about hunger, both emotional and physical, set in India and the United States.

Beginning in the early 1990s, Anita Desai began to teach at universities in England and the United States and now teaches in the Program of Writing at the Massachusetts Institute of Technology, as its first professor of fiction writing in twenty years.

Dividing her time between India, England, and the United States, has made Anita Desai one of the truly international writers of our times, yet she has said that she feels that she is always on the outside looking in. Perhaps it is her ability to see cultures, including her own, from the outside that makes her such a brilliant writer. She has inspired many young writers, both in India and the United States, to begin their own careers. Among them is her youngest daughter, Kiran, who has published her own first novel. Kiran, like many young people today, says she feels at home anywhere in the world, no doubt thanks to the bridge of understanding her eloquent mother has helped build between East and West.

Life's
Big Questions

Since the dawn of consciousness, people have asked: Where did this huge, amazing world come from? Do our lives have a purpose? Why are there illness, death, and war? Why do we hurt one another when what we really want is to love and be loved? People around the world—saints, mystics, and philosophers—have sought to answer such questions through spiritual doctrines and practices and to express their experience through poetry and song. Humanity's most ancient literature, much of it composed by women, comes from spiritual traditions around the world—Taoist, Hindu, Buddhist, Jewish, Christian, and Muslim—including hymns and prayers that have been handed down to us as poetry. In one way or another, their authors have tried to express that life is part of a greater whole that gives it meaning. And, they say, this world is sacred. This section includes two such poets, one ancient and one modern.

Women have also used fiction to express longing, joy, or awe at the magical and fleeting nature of the world. In fact, looking back over the lives of the women you've met in this book, it's possible to say that each has been inspired by life's marvelous possibilities. And each has tried to answer the important questions of their own lives in different ways. Our literary journey ends with a brilliant science fiction and fantasy author who uses imagination to find creative and open-ended answers to life's big questions, and who inspires us to do the same.

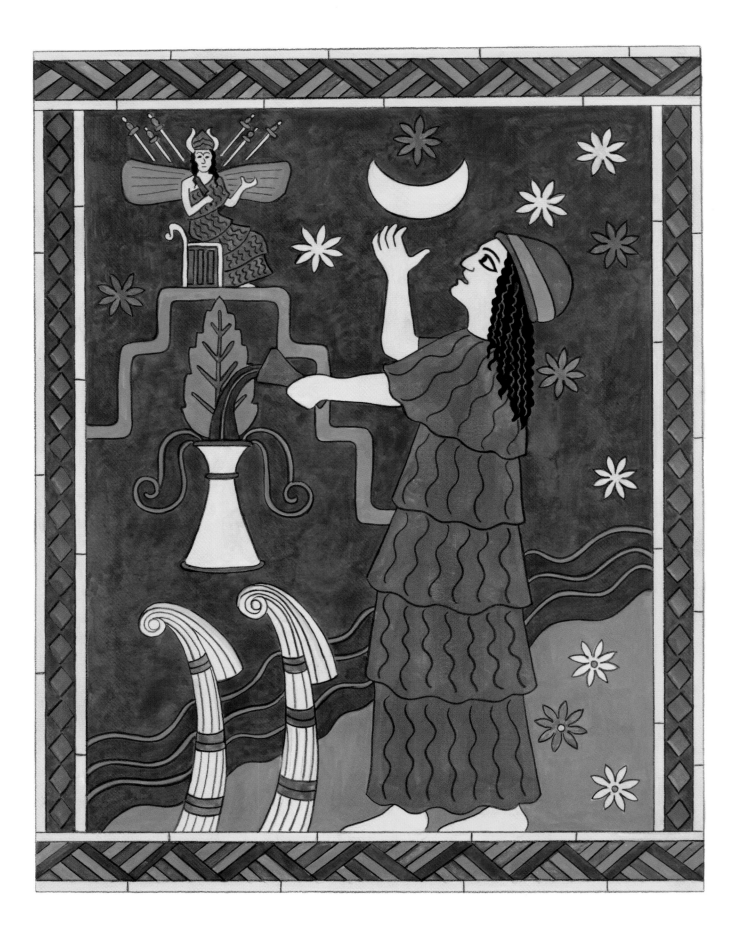

ENHEDUANNA

[circa 2300 B.C.]

"...and she goes out
white-sparked, radiant
in the dark vault of evening's sky
star-steps in the street
through the Gate of Wonder"
—from *Inanna and Mount Ebih,*
translated by Betty de Shong Meador

Sometime around 2300 B.C. in the "Fertile Crescent" of Mesopotamia, the scorching sun rises over the city of Ur in ancient Sumer. It first gilds the temple's tall ziggurat in the heart of the city, then shines on thick-walled brick buildings, protective city walls, and groves of date-palm trees. Rising higher, its reflection shimmers on the life-giving Euphrates River, where fishermen cast nets. Farmers check the dykes and ditches that collect and channel water from the river to grapevines and grain fields. Bakers sell warm flat breads to the artisans heading toward tanneries or pottery or brick factories, sheep and goats rustle in pens near the main market, and merchants open stalls offering everything from imported lapis lazuli to locally caught wild ducks. Scribes and teachers sharpen styluses and set out small wet clay slabs for writing upon, while mothers hurry their reluctant sons off to scribal school before settling down to spin or weave. Daughters tend the family garden plot, picking cucumbers, beans, or onions for a later meal.

Meanwhile, in the city's whitewashed temple compound, the daily

offerings and prayers to Ur's patron deity, the moon god Nanna, have already been made. Now, inside one temple, in the cool, quiet semidarkness, a priest pours a special offering, perhaps milk, into a sacred bowl standing before a new shrine dedicated to the goddess Inanna. Behind him stands the High Priestess, dressed in a gown of red pleated flounces, and behind her stand two attendants, one holding a cup or incense burner. We know these details because the priestess had a bas-relief (flat sculpture) of this very scene carved on an alabaster disc in order to commemorate it. When archaeologists unearthed it 4,300 years later (Agatha Christie's husband was one of them), they believed it had been deliberately smashed.

We can guess one further ceremonial detail: During the ritual, the High Priestess likely chanted praises or sang hymns to the deity of this shrine, as archaeologists also found forty-eight praises, prayers, and sad songs that she composed. Her name was Enheduanna, said to be the earliest known author in history.

Her longest and most passionate prayers and praises were to Nanna's daughter Inanna, "Lady of Largest Heart," who was Enheduanna's personal goddess. For hundreds of years after Enheduanna's death, student scribes painstakingly copied her poems on cuneiform tablets, thereby preserving them long after Sumer had disappeared. And thousands of years later, Inanna is still remembered as Venus, Roman goddess of love and the morning star, or as Ishtar, Babylonian and Assyrian goddess of love and war. Enheduanna's poems gave this "large-hearted" goddess lasting life, while other Sumerian deities faded away.

Sumer was one of the first great civilizations in history. Sumerians developed writing, the wheel, both for carts and for making pottery, a mathematical system that we still use when telling time or describing the degrees of a circle, and even the first drinking straws—three feet long, solid gold, and used for drinking beer from large vats! They also told stories of a monstrous flood, a good man, and an ark, along with several other legends that later became part of Judaism, Christianity, and Islam.

Religion was all-important. People *saw* the entire world as alive and full of sacred power. Gods and goddesses were thought to be in nature, as for example, in thunder, stars, air, or in water, and even in dykes, spindles, and plows, empowering people to perform their tasks properly. Without the

gods' blessings, crops withered and animals sickened and died. An entire city could be swept away by flood, drought, or war, so each city had a special god or goddess to oversee its welfare. Huge temple complexes housed statues of the major gods and their mates and children, plus various lesser spirits. Priests and priestesses, especially the High Priestess, honored their city's protector god by bathing the statues, and symbolically offering them food, burning incense, and by singing and playing music to them. Hundreds of people worked for the temples to provide everything from pottery and textiles to food and art. Enheduanna oversaw all these activities.

Her father was the first known emperor in history and the model for all later hero-kings. He called himself Sargon ("Lawful King"). According to ancient legend, a gardener found Sargon as a baby, floating in a basket among river reeds, and raised him as his own. The youth became an assistant to the king of the city of Kish in the north of Sumer, then broke away to found his own city, Akkad. He eventually conquered all of Sumer, including the powerful allied southern cities of Ur and Uruk; created a centralized government; and pursued trade as far away as India.

Though he and his northern armies were Semitic and had their own names for the deities they shared with all of Sumer, Sargon established authority over religion throughout Sumer by installing Enheduanna as High Priestess in Ur and possibly Uruk. She was probably quite young when she

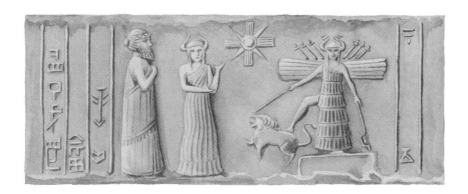

Cylinder seals were rolled across wet clay to make "signatures." Enheduanna's might have looked like this, featuring her and her father worshipping Inanna as the goddess of war.

became a priestess, and she took on her role with such dedication that during her long career she changed the face of Sumerian religion.

Ordinary citizens relied upon personal gods, prophecy, lucky charms, and magic spells to protect them, and depended upon priests and priestesses to guide them. Enheduanna was such a guide. She lived in the temple compound, in a special area containing a shrine devoted to Nanna's wife Ningal. As High Priestess she carried within her the living power of Ningal. So, in addition to Nanna, she tended to Ningal—and to their daughter Inanna. Beyond the daily rituals, she sometimes slept on a special "fruitful, shining couch" to invite dreams that only she could interpret. She traveled to other cities as well, composing hymns for their protector gods. Also, once a year she "married" Nanna, perhaps spending the night alone in a room atop the ziggurat, awaiting a visit from the god in a dream.

Inanna was already popular all across Sumer. In Ur alone, ten temples would be built for her, one atop the previous one, for over three thousand years. Known as Ishtar in the north, her image was on every Semitic king's war banners. She was particularly the protector god of Sargon's city of Akkad, and had "chosen" him to become emperor. The ability to grant and take away kingship was one of Inanna's special powers. Enheduanna used her poetic gifts to reinforce her father's claim to rightful rule by composing hymns to Inanna for use in other cities, so the goddess was worshiped everywhere. She also inspired people to turn to Inanna through her own steady devotion to her beloved goddess throughout the ups and downs of her own life. Her boldly beautiful hymns of praise reveal Inanna's large-hearted nature, which embraced all existence.

Inanna expressed the union of all apparent opposites—light and dark, love and hate, even heaven and earth, gentle peace and brutal war. She stood for the intelligent pattern that lay under the world, which could never be predicted or controlled. Enheduanna saw Inanna everywhere, in the kiss on a baby's cheek and in the gore of battle. In one lament, her personal distress as well as her loyalty to her goddess remind readers of the biblical Job thousands of years later. Since Ur was the original home of the Biblical father Abraham and his people, some speculate that her poems may have been the inspiration for Job's lament. Through her poetry, Enheduanna fused Inanna with Ishtar for all time. Enheduanna

also raised Inanna to an even higher status by presenting the goddess's many divine powers as greater than those of all other Sumerian gods.

Toward the end of Sargon's long reign, several cities, including Uruk and Ur, revolted against his rule and destroyed temples he had commissioned. The rebels deposed, humiliated, and banished Enheduanna. One of her greatest hymns dates from shortly after this upheaval. Ordinarily, as a city's fortunes waxed and waned, so did the "strength" of its deity, so as both Sargon's daughter and High Priestess, Enheduanna called upon Inanna to prove her superior power. After describing Inanna's many divine powers she compared the goddess to a storm of destruction, and begged her first to crush the rebel leader who had in effect banished them both, and then to abandon her dangerous fury before it went too far. Her magnificent prayers shake us with their passion. Eventually, Sargon or one of his nephews did put down the rebellion, and Enheduanna returned as High Priestess. With Enheduanna back in power, it must have seemed that Inanna was indeed greater than any of the other gods, even the oldest and most powerful of them.

After her death, Sumerians deified Enheduanna herself, and they never forgot her poetry. Her father's kingdom, however, was eventually swept away by barbarian tribes from the eastern mountains, and his city of Akkad vanished. Inanna/Ishtar's star also faded with the rise of a male-oriented worship of one god. Yet, after Ur was excavated in the early twentieth century, and Enheduanna's timeless voice rose again out of its ruins—fierce, awe-struck, and joyous—we are reminded that, while names and customs change, the heart does not.

GABRIELA MISTRAL

(LUCILA GODOY ALCAYAGA)

[1889–1957]

"All-round
The stars are boys in a round dance
watching the world and playing.
Wheatstalks are waists of girls
Playing at swaying…at swaying…
The rivers are boys in a round dance
playing at being the sea, the storms.
The waves are girls in a round dance
playing at holding the Earth in their arms."
—from *Ternura*, translated by Ursula K. Le Guin

One day in 1898, in a country schoolhouse set in a narrow valley in the Chilean Andes, a little blond nine-year-old girl stands trembling before her teacher, her green eyes filling with tears. School supplies are missing and the teacher, who is blind, is accusing the girl of theft, since she's responsible for them. But Lucila Godoy Alcayaga is innocent. She's just such a timid dreamer that the other children easily steal supplies when she's not looking. They also bully her mercilessly, something the teacher never sees. In her rage, the teacher expels Lucila from school, calling her a "mental defective." Outside the classroom, Lucila's classmates shout insults and throw rocks at her. She runs past vineyards and orchards to her home, where she falls sobbing into her mother's comforting arms. While that day will scar Lucila's heart, it also marks the beginning of her mission to teach children how to love.

Lucila, or Gabriela Mistral, as she is known today, was born in a little town in northern Chile. Her family—father, mother, half-sister, and grandmother—was of Basque and Indian, Catholic and Jewish descent.

Her father called himself a free spirit and abandoned his family when Lucila was only three. Although she kept her feelings to herself, the wound of losing him was the first of many that never healed.

The family struggled to make ends meet with her mother and half-sister both teaching school. But everyone cherished Lucila, reading Bible stories to her and teaching her how to read and write. Like Enheduanna, she loved and felt at one with the natural world. The orchards she played in, the animals wild and tame around her home, the river flowing nearby, and the blue skies and starry nights all seemed to her like the Bible come to life.

After her disastrous school experience, Lucila studied at home much of the time, aiming for a teaching certificate. Recalling her own school problems as well as the loving attention she received at home, she already knew how *she* wanted to teach: strictly, fairly, yet lovingly. By the age of fifteen, she was working as a teacher's assistant and writing articles and poems for local newspapers.

Between 1906 and 1907, she had a stormy romance with a young man. Two years later, he shot himself for reasons that had nothing to do with her. But Gabriela took his death to heart, since all he had left behind was a blank postcard with her name on it. She never told even her closest family how she felt. Instead, she wrote heartbreaking poetry about her dead sweetheart.

In 1910, she received official approval and began teaching, using song, dance, and poetry to reach her students. She was a dramatic success. She taught more than facts and figures, trying to waken children to the vastness of the world, its sacredness, and the need to respect all other beings. She would always consider teaching to be her truest calling.

In 1912, Lucila began studying with an organization called the Theosophical Society, which tried to blend all the great world religions into one. Through yoga exercises and religious study she hoped to find relief from her aching heart, but it never stopped hurting—her heart only got bigger as she began to see how much suffering there is in the world. So she shared that big heart and her vision of universal love with her students, seeing in them hope for a future world of peace and understanding.

In 1914, under her pen name, Gabriela Mistral (Gabriela for the Archangel Gabriel, and Mistral after a French word for a cold, dry wind),

she sent in the poems she had written about her dead boyfriend to a national poetry contest. Her *Sonetos de la Muerte* (*Sonnets of Death*) won first prize and brought her instant fame. Until this time, there had been little original Chilean poetry; authors had imitated a traditional, flowery Spanish style. But Gabriela used powerful, earthy language and images of her native land. Her poetic works attracted attention from all over Latin America and she began writing for newspapers in countries like Brazil, Argentina, and Venezuela.

Sometime after 1914, Gabriela fell in love again, with a married man. Rather than become involved with him, in 1918 she asked for and received a transfer to the bleak southernmost school district in Chile, the first of a series of lonely moves she chose to make. There she taught and wrote, returning to her Christian roots and weaving spiritual themes into her poetry. She began behaving almost as a Biblical character: speaking slowly, as if chanting; wearing her hair severely; never wearing jewelry or makeup; and choosing only brown or gray for her simple dresses. Her influence as a poet and educator spread across Latin America.

By 1921, Gabriela had a new job, as a school principal in Santiago, Chile's capital, and her fame was reaching the United States. A group of admirers at Columbia University collected, and in 1922 published, the first book of her poems, *Desolacion* (*Desolation*), which included her early *Sonnets of Death*. They reflected the sadness of her early years and her yearning for love.

Despite her popularity, Gabriela never really felt at home anywhere. So, in 1922 she took advantage of her growing international reputation and accepted an invitation from the Mexican government to help reform its school system. From then on, she rarely returned to Chile. Nonetheless, in 1923, her country finally honored her by naming her Teacher of the Nation. And after she officially retired in 1925 at only the age of thirty-six, she received a special pension. She also became a consul for the Chilean government and one of its representatives to the League of Nations.

She lived the rest of her life in different European and American countries: Spain, Portugal, Italy, France, Brazil, Puerto Rico, Mexico, and the United States, to name a few. *Ternura* (*Tenderness*), poems dedicated to mothers and children, was published in Spain in 1924. In 1929, Gabriela

*In poor health and mourning for her dead son, Gabriela Mistral gracefully
accepted the Nobel Prize for Literature but could take no joy in it.*

adopted an orphaned nephew, Juan Miguel Godoy, fulfilling her desire
for her own child.

As her fame spread, honors poured in. She taught at several universities
in the United States and elsewhere, received honorary degrees from
American and European universities, and after 1935 traveled wherever
she wished as "minister plenipotentiary" for Chile. Always a foe of fas-
cism, she was horrified by Europe's slide into war and the growth of
dictatorships. Like Edith Wharton, she felt compelled to help the victims
of war. She published a book of poems in Argentina in 1938, *Tala*
(*Clearing*), donating its profits to Basque refugee children who had fled the
Spanish Civil War.

But while they were living in Brazil in 1943, eighteen-year-old Juan
Miguel died of arsenic poisoning. Although the official verdict was suicide,

Gabriela was convinced that a gang of neo-Nazi boys had murdered him. His death sapped her will to live, and the rest of her life was spent in a fog of ill health and sorrow, filled with constant travel to dull her pain. In 1945, she received the first Nobel Prize for Literature ever given to a Latin American (*all* the Latin-American countries had nominated her together), but she was too dispirited to rejoice. Yet it was her aching heart that had made Lucila into Gabriela, the great author whose poems were dedicated to love, mercy, and justice for everyone.

After World War II, Gabriela again became a Chilean delegate—this time to the newly formed United Nations. Her worldwide appeal for donations for poor children led to the founding of UNICEF, the branch of the UN dedicated to children's welfare.

Her last book of poems came in 1953. Called *Lagar* (*Winepress*), and the only one of her books first published in Chile, it expressed both Gabriela's sorrow and joy in life, her desire for a world of love and understanding, and despite everything, a confidence that the human heart can break and become bigger. She died in New York in 1957. Today she is thought of almost as a saint across Latin America, where many schools are named after her, and where children still learn her poetry and sing her songs of universal love.

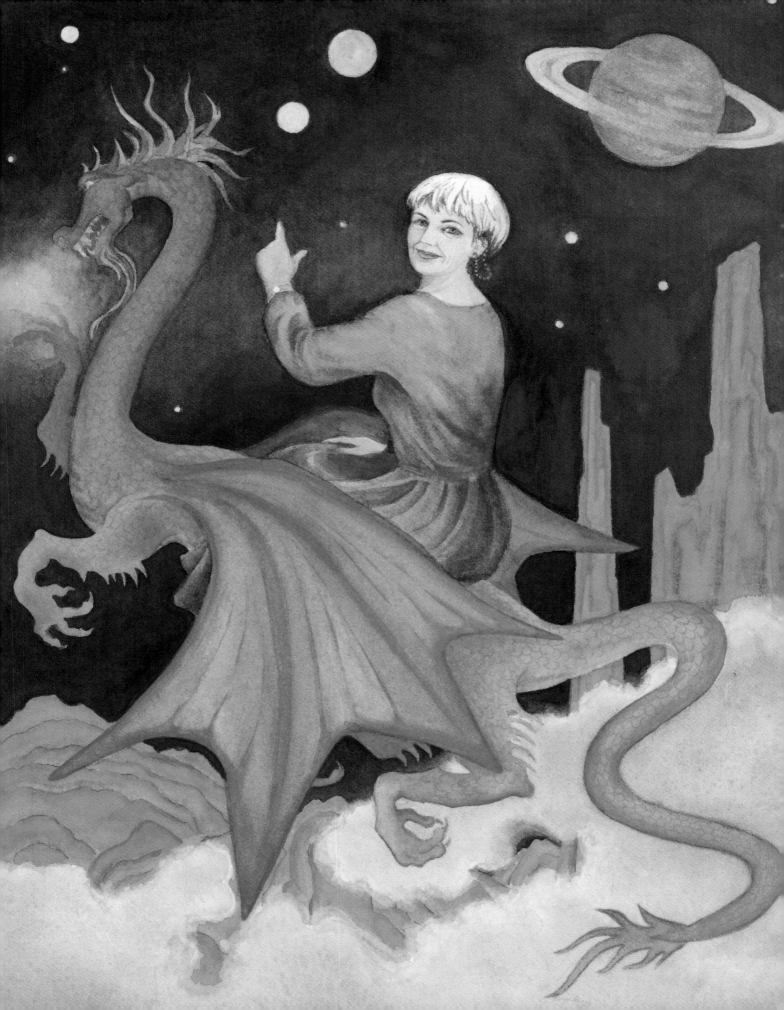

URSULA K. LE GUIN

(URSULA KROEBER)

[1929–present]

"I was brought up to think and to question and to enjoy."
—from a written interview with the author, 2001

On a hot, blue day in 1943, a slender, dark-haired girl of fourteen sets out for a lonely ramble among the rolling golden hills that surround her family's summer home, a ranch in northern California. Ursula Kroeber stops to rest in the shade of a huge solitary oak tree. A single bird calls; a breeze rustles the golden wild oats that blanket the hills—echoing the silence of her days. How alone she feels without her three older brothers beside her. They are far away, at war when they should be here at home playing family games, listening to their great-aunt tell stories around the campfire, or reading to one another in the evening—not fighting Nazis! No one knows whether they'll survive. She wonders how the world can be so beautiful, yet so full of cruelty and pain.

Although her brothers will eventually return home safely, these questions will linger in Ursula's mind. Eventually, they'll lead her toward a view of existence so vast that it takes in both the farthest reaches of the universe and the darkest depths of the human heart.

Ursula grew up in a large, loving family, surrounded by "the life of the mind." Her mother, Theodora, was a psychologist and gifted writer. Her

father, Alfred Kroeber, once a student of Franz Boas (also Zora Neale Hurston's mentor), headed the anthropology department at the University of California in Berkeley. His particular field of study was the rich heritage of the California Indians. A constant stream of visiting scholars, scientists, and philosophers from around the world, as well as Native American friends, enriched Ursula's growing-up years with their "talk and argument and discussion about everything," allowing her to see how many different ways there are to understand what the world is about. As well, her family loved music and literature, and Ursula dove into books of myths and legends (Norse myths were her favorite), science including both psychology and biology, and philosophy. And her parents encouraged Ursula to grow up both proud to be a woman and confident about her talents.

From the time she had learned to write at age five, she knew she would somehow combine all her interests, especially poetry and science. She wrote constantly and at age eleven submitted a science fiction story to a magazine. Though it was rejected, she steadily wrote poems, short stories, and journals. When she was fourteen she found a book in her family library that would influence her for a lifetime: the *Tao Te Ching*, written by a semi-legendary Chinese man, Lao Tzu, over two thousand years ago. Also her father's favorite book, it viewed light and dark, good and evil in the world as part of a great flow of being, and it gave wise advice on how to live in harmony with oneself and with the world.

Although she was exploring her inner life in a creative way, Ursula was shy in public. After enduring the "social torture" of high school, she attended Radcliffe College. There she almost fell apart after a painful love affair, nearly ruining her career before it had even begun. Pulling her life back together with support from her family, she went on to earn a master's degree at Columbia University in 1952 while completing her first full-length novel. She also won a Fulbright Scholarship to study in France. By then she had decided against a science career because it meant studying too much mathematics. She turned to literature instead. And, knowing that writing doesn't always bring large financial rewards, she intended to get a Ph.D. degree so she could teach college students.

However, in 1953, on board the ship that was taking her to study in France, Ursula met a young historian from Georgia, Charles Le Guin. They fell in love and married in that same year. Without the pressure to make a separate living, Ursula Le Guin was able to follow her heart; while

In both her writing and her life,
Ursula sees the world as wondrous and whole.

Charles taught at a series of universities, she wrote. They finally settled in Portland, Oregon, in 1959, where they still live. Between 1957 and 1964 they also had three children and, as with Toni Morrison and Anita Desai, Ursula Le Guin continued writing, but only when the children were asleep or away. Charles participated directly in her career, both by encouraging her to keep going when her novels didn't sell right away, as well as in helping to raise their children, an uncommon practise in the 1950s and 1960s. Their marriage became a true life partnership.

Nonetheless, though she had a few poems and a short story published in the 1950s, her career did not advance. Often set in an imaginary Central European country called Orsinia, her stories and novels reflected her interest in European history and her German and Polish ancestors. They explored how the human spirit can survive the kind of war, lack of human rights, and cruelty that real Europeans had suffered from for centuries. But, though Isak Dineson was writing similar stories, Ursula Le Guin's fit none of the categories that American publishers recognized.

In 1960, her father died suddenly—while losing him was a deep blow, she felt that it also forced her into true adulthood. One of the changes she made as a result of his death was to rethink where she wanted to take her writing. She turned to science fiction again, which allowed her vivid imagination to blossom fully and which also fit a recognizable publishing category. By 1962, she was not only publishing her work but was also transforming the nature of science fiction, which had generally been thought of as mere light entertainment.

Ursula Le Guin broke new ground by using science fiction and fantasy to explore what it means to be truly human. She not only used elegant, seemingly simple language, evocative imagery, and convincing characters, but also drew upon her interest in Native American traditions, Norse myths, psychology, and Taoism. In many ways, her stories were like classic hero quests of old, but they added new elements. Often the hero or heroine was an outsider observing a new world and learning to cope with its mysteries, and usually the plots ended, not necessarily happily, but with the birth of new possibilities. Thus, the main characters did not simply slay enemies; they also grew to know themselves better, and in some stories, came to understand something about reality itself.

Ursula Le Guin's best-loved work included the Earthsea novels, *A*

Wizard of Earthsea, The Tombs of Atuan, and *The Farthest Shore,* written for teenagers, although adults also love them. Like many fantasy novels, the Earthsea novels are filled with magic and adventure, but hers have an added dimension. Their heroes are young people growing up and coming to terms with their inner needs and their outer destinies, learning not to fear change but to find renewal within it. Reading them, many teens felt that she had given them a focus when they felt utterly confused about who they were and why they were alive. In addition, Ursula Le Guin has written books for children, the Catwing series.

Over the years, she has become wildly popular with readers of all ages—and with critics. Among her many honors, she has received five Hugo and five Nebula Awards, the highest honors given for science fiction. As well, she has won many literary awards, including a National Book Award. Scholarly books have explained her philosophy, while fans set up websites around the world, from Russia to the United States. Her early Orsinian books found publishers, too, adding to her huge reputation.

Busy publishing novels, short stories, poetry, a translation of the *Tao Te Ching,* and, currently, a translation of the collected poems of Gabriela Mistral, Ursula Le Guin also supports causes from feminism to conservation of the environment, while teaching in universities and leading writing workshops in the United States and abroad. On her rare guest appearances at "sci-fi" conventions, where people often show up in wild garb, she avoids flashiness, although she does wear a dangly homemade Star Trek "Bajoran" earring. Quietly self-possessed, she's always willing to listen to and encourage budding new science fiction authors. Her hair now gray, she has become what every woman can aspire to be: a wise woman who embodies the wisdom of the past while pointing the way to the future.

BIBLIOGRAPHY

You can also find out more about all of these women on the Internet. A good place to start is *A Celebration of Women Authors* (http://digital. library.upenn.edu/women), which has links to many other sites. Also, for decades, producers have mined the gold of women's writing for motion picture and television ideas. Authors whose works or life stories have been adapted for large or small screen include Beatrix Potter, Laura Ingalls Wilder, Charlotte and Emily Brontë, George Sand, Edith Wharton, Isak Dineson, Agatha Christie, Lillian Hellman, Toni Morrison, Anita Desai, Ursula Le Guin—and Jane Austen, possibly the most popular of all. Also, look for unusual adaptations of many of these authors' works, from a ballet based on Beatrix Potter stories to an updated movie comedy, *Clueless*, based on Jane Austen's *Emma*. Happy reading and happy watching!

HELEN BEATRIX POTTER

Aldus, Dorothy. *Nothing is Impossible: The Story of Beatrix Potter*. New York: Atheneum, 1969.

Buchan, Elizabeth. *Beatrix Potter*. London: Hamish Hamilton, 1987.

Lane, Margaret. *The Tale of Beatrix Potter*. Hammondsworth and New York: Frederick Warne and Co., 1946, 1985.

Linder, Leslie. *A History of the Writings of Beatrix Potter*. London and New York: Frederick Warne and Co., 1971.

Taylor, Judy. *Beatrix Potter: Artist, Storyteller and Countrywoman*. Hammondsworth and New York: Frederick Warne (a division of Penguin Books), 1986.

LAURA ELIZABETH INGALLS WILDER

Anderson, William. *Laura Ingalls Wilder Country*. New York: HarperPerennial, 1988.

Blair, Gwenda. *Laura Ingalls Wilder*. New York: G. Putnam's Sons, 1981.

Giff, Patricia Reilly. *Laura Ingalls Wilder: Growing Up in the Little House*. New York and London: Puffin Books, 1987.

Greene, Carol. *Laura Ingalls Wilder: Author of the Little House Books*. Chicago: Children's Press, 1990.

Zochart, Donald. *Laura*. New York: Avon Books, 1976.

LADY MURASAKI SHIKIBU

Collcut, Martin, Marius Jansen, and Isao Kumakura. *Cultural Atlas of Japan*. New York: Facts on File, Inc. and Oxford: Equinox Ltd., 1988.

Keene, Donald. *The Pleasures of Japanese Literature*. New York: Columbia University Press, 1988.

Leonard, Jonathon Norton. *Early Japan*. New York: Time-Life Books, 1968.

Morris, Ivan. *The World of the Shining Prince*. New York: Alfred A. Knopf, 1978.

Murase, Miyeko. *Iconography of the Tale of Genji*. New York and Tokyo: Weatherhill, 1983.

Varley, H. Paul. *Japanese Culture: A Short History*. New York and Washington: Praeger Publishers, 1973.

JANE AUSTEN

Austen-Leigh, James. *Memoir of Jane Austen*. London: Century Hutchinson Ltd., 1987. First published in 1870.

Cecil, Lord David. *A Portrait of Jane Austen*. New York: Hill and Wang, 1978.

Lane, Maggie. *Jane Austen's England*. New York: St. Martin's Press, 1986.

Laski, Marghanita. *Jane Austen and Her World*. London: Thames and Hudson, 1969.

Nokes, David. *Jane Austen: A Life*. New York: Farrar, Straus and Giroux, 1997.

Pool, Daniel. *What Jane Austen Ate and Charles Dickens Knew*. New York: Simon & Schuster, 1993.

Video: *Jane Austen's Life*. Englewood, New Jersey: American Home Treasures, Inc.

GEORGE SAND/AURORE DUPIN DUDEVANT

Atwood, William G. *The Lioness and the Little One*. New York: Columbia University Press, 1980.

Barry, Joseph. *Infamous Woman: The Life of George Sand*. New York: Doubleday & Company, Inc., 1977.

Dickenson, Donn. *George Sand: A Brave Man, The Most Womanly Woman*. Oxford, New York, and Hamburg: Berg Publishers Limited, 1988.

Jack, Belinda. *George Sand: A Woman's Life Writ Large*. London: Chatto & Windus, 1999; New York: Alfred A. Knopf, 1999.

Marois, André. *Lélia: The Life of George Sand*. Translated from the French by Gerard Hopkins. New York: Harper & Brothers Publishers, 1953.

Winwar, Frances. *The Life of the Heart: George Sand and Her Times*. New York and London: Harper & Brothers Publishers, 1945.

CHARLOTTE BRONTË

Bentley, Phyllis. *The Brontës and Their World*. London: Thames and Hudson, 1969.

Fraser, Rebecca. *The Brontës: Charlotte Brontë and Her Family*. New York: Crown, 1988.

Gaskell, Mrs. E. C. *The Life of Charlotte Brontë*. London and New York: Penguin Books, 1998. First published in 1857.

Gordon, Lyndall. *Charlotte Brontë: A Passionate Life*. New York and London: W. W. Norton & Company, 1994.

Peters, Margaret. *Unquiet Soul: A Biography of Charlotte Brontë*. New York: Doubleday & Company, Inc., 1975.

Wilks, Brian. *The Brontës*. London and New York: Hamlyn, 1975.

EDITH JONES WHARTON/EDITH NEWBOLD JONES

Benstock, Shari. *No Gifts from Chance: A Biography of Edith Wharton*. London, New York, and Toronto: Penguin Books (Charles Scribner's Sons), 1994.

Lewis, R. B. *Edith Wharton: A Biography*. New York and San Francisco: Harper & Row, Publishers, 1975.

Wharton, Edith. *A Backward Glance*. New York: Simon and Schuster, 1998. First published in Great Britain in 1933 by William Tyler publishers.

ISAK DINESEN/KAREN DINESEN BLIXEN

Blixen, Karen. *Out of Africa and Shadows on the Grass*. Hammondsworth and New York: Penguin Books, 1985. Originally published separately in 1937 and 1960.

———. *Letters from Africa: 1914–1931*. Edited by Frans Lasson, translated by Anne Born. Chicago: The University of Chicago Press, 1981.

Blixen, Thomas. *My Sister, Isak Dinesen*. London: Michael Joseph Ltd., 1975.

Hannah, Donald. *Isak Dinesen and Karen Blixen*. London: Putnam and Co., 1971.

Lasson, Frans, and Clara Svendson. *The Life and Destiny of Isak Dinesen*. Chicago and London: The University of Chicago Press, 1970.

Migel, Parmenia. *Titania*. New York: Random House, 1967.

Thurman, Judith. *Isak Dinesen: The Life of a Storyteller*. New York: St. Martin's Press, 1982.

ZITKALA-ŠA/GERTRUDE SIMMONS BONNIN

Rappaport, Doreen. *The Flight of Red Bird*. New York, London, and Toronto: Puffin Books (children's division of Penguin Books), 1997.

Thomas, David Hurst, et. al. *The Native Americans: An Illustrated History*. Atlanta: Turner Publishing, Inc., 1993.

Zitkala-Ša. *American Indian Stories*. Lincoln and London: University of Nebraska Press, 1985. First published in 1921.

Zitkala-Ša. *Old Indian Legends*. Lincoln and London: University of Nebraska Press, 1985. First published in 1901.

AGATHA CHRISTIE/AGATHA MILLER/
LADY AGATHA MALLOWAN

Christie, Agatha. *An Autobiography*. London: William Collins Sons and Company, Ltd., and New York: Dodd Mead and Company, 1977.

Gill, Gillian. *Agatha Christie: The Woman and Her Mysteries*. New York: The Free Press, a division of Macmillan, Inc., and Toronto: Collier Macmillan Canada, 1990.

Keating, H.R.F., editor. *Agatha Christie: First Lady of Crime*. New York: Holt, Rinehart and Winston, 1977.

Morgan, Janet. *Agatha Christie: A Biography*. London: HarperCollins Publishers, and New York: Knopf, 1984.

Osborne, Charles. *The Life and Crimes of Agatha Christie*. New York: Holt, Rinehart and Winston, 1982. Reissued by Macmillan, 1990.

Video: Morgan, Janet, et. al. *Agatha Christie—How Did She Do It?* Home Vision, A PMI Company, 1986.

ZORA NEALE HURSTON

Bontemps, Arna. *The Harlem Renaissance Remembered*. New York: Dodd, Mead & Co., 1972.

Hemenway, Robert E. *Zora Neale Hurston: A Literary Biography*. Urbana, Chicago, and London: University of Illinois Press, 1977.

Howard, Lillie P. *Zora Neale Hurston*. Boston: Twayne Publishers, a Division of G. K. Hall & Co., 1980.

Hurston, Zora Neale. *Dust Tracks on a Road: An Autobiography*. Urbana and Chicago: University of Illinois Press, 1984. First published in 1942.

———. *Folklore, Memoirs, and Other Writings*. New York: The Library of America, 1995.

———. *Novels and Stories*. New York: The Library of America, 1995.

Lowe, John. *Jump at the Sun: Zora Neale Hurston's Cosmic Comedy*. Urbana and Chicago: University of Illinois Press, 1994.

LILLIAN HELLMAN

Bryer, Jackson, editor. *Conversations with Lillian Hellman*. Jackson and London, University Press of Mississippi, 1986.

Falk, Doris. *Lillian Hellman*. New York: Frederick Ungar Publishing Co., 1978.

Hellman, Lillian. *Three: An Unfinished Woman, Pentimento, and Scoundrel Time*. Boston and Toronto: Little, Brown and Company, 1979.

Lederer, Katherine. *Lillian Hellman*. Boston: Twayne Publishers, 1979.

Rollyson, Carl. *Lillian Hellman: Her Legend and Her Legacy*. New York: St. Martin's Press, 1988.

ELIZABETH BISHOP

Barry, Sandra. *Elizabeth Bishop: An Archival Guide to Her Life in Nova Scotia*. Hanstport, Nova Scotia: Lancelot Press Limited, 1996.

Bishop, Elizabeth. *The Complete Poems: 1927–1979*. New York: The Noonday Press (Farrar, Straus and Giroux), 1983.

———. *The Collected Prose*. New York: The Noonday Press (Farrar, Straus and Giroux), 1984.

———. Robert Giroux, editor. *One Art: Letters, Selected and Edited*. New York: Farrar, Straus and Giroux, 1994.

Fountain, Gary and Peter Brazeau. *Remembering Elizabeth Bishop: An Oral Biography*. Amherst: University of Massachusetts Press, 1994.

Millier, Brett. *Elizabeth Bishop: Life and the Memory of It.* Berkeley, Los Angeles, and Oxford: University of California Press, 1993.

Travisano, Thomas. *Expulsion from Paradise: Elizabeth Bishop, 1927–1957.* Jolicure, New Brunswick: Anchorage Press.

TONI MORRISON/CHLOE ANTHONY WOFFORD

Century, Douglas. *Toni Morrison.* New York and Philadelphia: Chelsea House Publishers, 1994.

Commire, Anne, editor. *Something About the Author.* Chapter on Toni Morrison. Gale Research Inc., 1989.

Furman, Jan. *Toni Morrison's Fiction.* Columbia: University of South Carolina Press, 1996.

Samuels, Wilfred D. and Clenora Hudson-Weems. *Toni Morrison.* Boston: Twayne Publishers, 1990.

Timehost on Time.com. Interview with Toni Morrison on January 21, 1998
 http://www.time.com/time/community/transcripts/chattr012198.html

Bragg, Melvyn and Alan Benson. *Toni Morrison.* Home Vision Video, 1987.

ANITA DESAI/ANITA MAZUMDAR

Choudhury, Bidulata. *Women and Society in the Novels of Anita Desai.* New Delhi: Creative Books, 1995.

Desai, Anita. Written interview with the author.

Indira, S. *Anita Desai as an Artist.* New Delhi: Creative Books, 1994.

Jain, Jasbir. *Stairs to the Attic: The Novels of Anita Desai.* Jaipur: Printwell Publishers, 1987.

Jena, Seema. *Voice and Vision of Anita Desai.* New Delhi: Ashish Publishing House, 1989.

———. *Carving a Pattern Out of Chaos.* New Delhi: Ashish Publishing House, 1990.

ENHEDUANNA

Crawford, Harriet. *Sumer and the Sumerians.* Cambridge and New York: Cambridge University Press, 1991.

Goodison, Lucy and Christine Morris. *Ancient Goddesses.* London: British Museum Press, 1998.

Hallo, William and J.J.A. Van Dijk. *The Exaltation of Inanna.* New Haven and London: Yale University Press, 1968.

Meador, Betty de Shong. *Inanna, Lady of Largest Heart: Poems of the Sumerian High Priestess*

Enheduanna. Austin: University of Texas Press, 2000.

Splendors of the Past: Lost Cities of the Ancient World. Washington, DC: Special Publications Division, National Geographic Society, 1981, 1986.

GABRIELA MISTRAL/LUCILA GODOY ALCAYAGA

Agosin, Marjorie, translated by Maria Giachetti. *Gabriela Mistral: A Reader.* Fredonia, New York: White Pine Press, 1993.

Arce De Vazquez, Margot, translated by Helene Masslo Anderson. *Gabriela Mistral: The Poet and Her Work.* New York: New York University Press, 1964.

Dana, Doris. *Selected Poems of Gabriela Mistral.* Baltimore: The Johns Hopkins Press, 1971.

Taylor, Martin C. *Gabriela Mistral's Religious Sensibility.* Berkeley and Los Angeles: University of California Press, 1968.

URSULA K. LE GUIN/URSULA KROEBER

Bucknall, Barbara J. *Ursula K. Le Guin.* New York: Frederick Ungar Publishing Co., 1981.

Cummins, Elizabeth. *Understanding Ursula K. Le Guin.* Columbia, South Carolina: University of South Carolina Press, 1990.

De Bolt, Joe, editor. Ursula K. Le Guin: *Voyager to Inner Lands and to Outer Space.* Port Washington, New York and London: Kennikat Press (National University Publications), 1979.

Le Guin, Ursula K. *Dancing at the Edge of the World: Thoughts on Words. Women. Places.* New York: Grove Press, 1989.

————. Written interviews with the author, 2001.

Spivack, Charlotte. *Ursula K. Le Guin.* Boston: Twayne Publishers, 1984.

GLOSSARY

Addison's disease: In the past a deadly wasting disease that today can be cured with drugs.

Assyria: Ancient kingdom of northern Mesopotamia, located in present-day northern Iraq and southeastern Turkey.

Babylonia: Ancient Mesopotamian area that included Sumer in the south and Akkad in the north.

Basque: Member of a people who live in the western Pyrenees mountains dividing Spain from France.

Buddhism: Asian religion based on the teachings of Siddhartha Gautama (c. 563–483 B.C.), known as the Buddha.

Bureau of Indian Affairs: Organization established by the U.S. government in 1824 to absorb Native American cultures into mainstream American life. Currently it is in charge of Native American lands, education, and rights.

Canadian Maritimes: Three easternmost provinces of Canada: New Brunswick, Nova Scotia, and Prince Edward Island.

Caucus Room: Meeting room in Washington, D.C., where Congress members work; here, specifically, the room used by the House Un-American Activities Committee (HUAC) for its public hearings on Communism in the entertainment industry.

Chippewa: Native American tribes also known as the Ojibwa, Ojibwe, or Ojibway, who lived in what would become Canada and the United States, from the Great Lakes to North Dakota.

Communism: Social system in which all goods are owned in common; private property does not exist. Spelled with a capital C, it refers to a political philosophy that aims to eliminate social classes and cause the downfall of capitalism through violent revolution.

Fascism: Political philosophy that ignores individual liberty and the equality of all human beings in favor of duty to the state.

Fertile Crescent: Area of Mesopotamia, located on productive, crescent-shaped land between the Tigris and Euphrates Rivers, where several ancient civilizations arose. It is now part of Syria and Iraq.

Fifth Amendment: Addition to the U.S. Constitution that includes a provision that people have the right not to testify against themselves or their family members.

Fulbright Scholarship: U.S. government international student exchange program conceived in 1946 by Senator J. William Fulbright.

Girl Guides: Members of an organization in England and other European countries, comparable to the Girl Scouts of the United States of America.

Great Depression: The longest, deepest economic slump in modern history, characterized by widespread poverty. It began in 1929 in the United States and lasted until about 1939.

Great War: World War I; the First World War.

Heian era: Period in Japanese history (794–1192) named after the imperial capital Heian-kyo (present-day Kyoto).

Himalayas: Mountain range, the highest in the world, along the northern border of India.

Hinduism: Religion, practiced largely in India, that came into being by 1500 B.C.

House Un-American Activities Committee (HUAC): Congressional body established in 1947 to investigate groups whose activities were thought to be anti-American.

Job: Biblical character stripped by God of everything from family to home to test his faith; subject of the Book of Job.

Koel bird: Species of cuckoo that lives in Asia.

Lake District: Area in northwestern England with large lakes and steep hills, now a popular national park.

League of Nations: International organization founded in 1919, after World War I, to encourage unity and harmony among countries.

It was replaced by the United Nations in 1946.

Legion of Honor: Highest honor given by the French republic for heroism, created in 1802 by General Napoleon Bonaparte.

Mughal (also Moghul or Mongol) Empire: Muslim dynasty that ruled most of northern India from 1526 to 1761.

Muslim: One who practices the religion known as Islam, founded in the sixth century by the prophet Muhammad.

Nairobi: Capital of Kenya, in East Africa.

Napoleonic Law: Also called the Code of Napoleon. Set of laws dating from 1804, based mainly on common sense; remains the law of France.

National Book Award: Prize given since 1950 to American writers for fiction, nonfiction, poetry, and young people's literature by the National Book Foundation.

National Council on the Arts: Organization that advises the National Endowment for the Arts, the government agency that funds arts projects in the United States.

National Trust (National Trust for Places of Historic Interest or Natural Beauty): Organization founded in the United Kingdom in 1895 to care for important historic buildings and areas of great beauty in England.

Nazi Germany: Period that began in 1933, during the Great Depression, when Germans voted Adolf Hitler president of the National Socialist, or Nazi, Party.

Nazism: Doctrines established by the National Socialist German Workers' party. They include total government control of politics and the economy headed by a supreme dictator; also, a belief in the superiority of certain racial groups.

Nobel Prize: Prestigious international award established by Alfred Nobel, a Swedish citizen, bestowed annually since 1901 upon winners in such categories as peace, literature, economics, and various sciences.

Nova Scotia: Maritime province of eastern Canada, north of Maine.

Old Delhi: Ancient half of the city of Delhi, capital of India.

Orient: The part of the world that faces east, toward the rising sun; generally, Eastern countries.

Ozark region: Also called the Ozark Plateau. Area of heavily forested hills and mountains located southwestward from Missouri to the Arkansas River.

Panama Pacific Exposition: Another name for the 1915 World's Fair in San Francisco.

Pan-Native: Organization whose membership is open to people of all Native American tribes, dedicated to saving their endangered cultures and spiritual values.

Prince of Wales: Traditional title given by the king of England to his heir since 1301, when Edward I conquered Wales and gave the title to his son.

Pulitzer Prize: One of several awards for American journalism, letters, and music given annually by Columbia University since 1917.

Queen Victoria: Queen of the United Kingdom of Great Britain and Ireland from 1837 to 1901.

Republic: Government or nation, like the United States, in which a few people are elected to represent the needs and wishes of all the other people.

Roaring Twenties: Rebellious decade following World War I, known for jazz, dancing, and drinking.

Roman: Citizen of the Roman Empire, which lasted from 27 B.C. to the fifth century A.D. Also, a citizen of Rome, Italy.

Semitic: Any of a group of Middle Eastern languages.

Spanish Civil War (1936–39): Bloody military revolt against the Republican government of Spain that led to a general civil war.

Sumer: Southern part of ancient Babylonia, in southern Mesopotamia, home to the earliest known Western civilization.

Taoism: Chinese spiritual philosophy based on the Tao Te Ching, written by Lao Tzu in the sixth century B.C.

INDEX